IMAGES
*of America*

LOST
BENZIE COUNTY

On the Cover: The Royal Frontenac Hotel, resting on the "island" separating Lake Michigan and Betsie Bay in Frankfort, was built by the Ann Arbor Railroad (AA) and opened in 1902. For 10 years, it operated as a summer resort. Vacationers arrived by steamship and railroad to take advantage of the cool lake breezes and long summer days. It burned in January 1912 and was never rebuilt. (Courtesy of the Benzie Area Historical Museum.)

IMAGES
*of America*

LOST
BENZIE COUNTY

Dr. Louis Yock for the
Benzie Area Historical Society

ARCADIA
PUBLISHING

Copyright © 2011 by Dr. Louis Yock for the Benzie Area Historical Society
ISBN 978-0-7385-8294-8

Published by Arcadia Publishing
Charleston, South Carolina

Printed in the United States of America

Library of Congress Control Number: 2009943770

For all general information, please contact Arcadia Publishing:
Telephone 843-853-2070
Fax 843-853-0044
E-mail sales@arcadiapublishing.com
For customer service and orders:
Toll-Free 1-888-313-2665

Visit us on the Internet at www.arcadiapublishing.com

# Contents

Acknowledgments — 6

Introduction — 7

1. Towns and Settlements — 9
2. Businesses — 33
3. Transportation — 71
4. Resorts — 99
5. Societies — 115

# ACKNOWLEDGMENTS

The people of Benzie County are proud of their history. For over 40 years, they have submitted thousands of pictures and scores of written historical accounts to the Benzie Area Historical Society. All of the photographs and caption descriptions in this book are taken from the collections so diligently managed by the past curators and volunteers of the Benzie Area Historical Museum. Their dedication endures on the shelves, and now in the computers, at the Mitchell Center for Benzie History in Benzonia. Selecting just over 200 pictures out of the thousands catalogued is a difficult task. Special acknowledgment must be made to those whose work made the choices for this book possible. Bill Rose, Bill Pearson, and Kay Noah have spent many hours gathering information and pictures about the ghost towns of the county. They quietly and uncannily find photographs and written words about things most have thought permanently lost to recorded history. Finally, a special thanks goes to Jane Purkis, whose knowledge about the collections and about the area's history provides an invaluable service to the county and anyone who wishes to research in the society's archives.

# INTRODUCTION

The history of Benzie County, like so many other counties in northern Michigan, is about trees and water—and about the people attracted by the wealth to be found in them, and those who simply like to live or vacation among them. This book is composed of photographs and accounts, given to the Benzie Area Historical Society and Museum, that chronicle the ever-changing succession of people and industries that have appreciated and used the trees and waters in different ways. Since the 1850s, large influxes of people have come and gone from the Benzie area, leaving behind a rich history. Much of what they did and accomplished is lost, but with a picture here, a postcard there, a memoir donated to the Benzie Area Historical Society, or an oral history transcribed by a dedicated volunteer, a better understanding about the past comes to light. The stories, legends, and tall tales of the lumberjacks mingle with the accounts of ships on stormy waters, as well as the photographs of the lumber mills, the ice flows in Frankfort Harbor, and the fishermen's nets drying on the docks, to take on a deeper significance.

For many of those who came to make their fortune with the trees, or just earn a living cutting, transporting, and processing them, the settlements they built were intended to be temporary. Even if they believed the supply of trees was infinite, they knew that the mill would eventually have to be disassembled and moved to the next stand and their shacks abandoned to the elements. This followed the long-established pattern in the Benzie area, beginning with the native peoples who came to hunt, fish, and collect the woodland fruits who lived in seasonal camps and villages while accomplishing their tasks. In fact, many of the men and women who labored in and around the lumber camps were native peoples who simply added lumbering to their seasonal rounds.

Many of the sites that served as temporary camps or villages are known only by a place name that lingers on in a memory, is found on an old map, or is mentioned in a yellowing newspaper listing. Photographs or postcards may exist, and they even may survive at the archives of the Benzie Area Historical Museum or in a shoebox in a closet, but the place and people may not be identified. Only those settlements for which the Benzie Area Historical Society has pictures of a publishable quality, and that are positively identified, are found in this short history. Many more places and pictures exist than are found in this volume.

As transportation improved, especially with the railroads and steamships, some of those temporary settlements gained a degree of permanence, with a factory or a depot that outlasted the initial lumber boom. Rather than being dismantled and moved, the mill was sold and retooled for its next use, sometimes processing a different species of tree and other times turned into a processing plant or warehouse for the up-and-coming agricultural industry. These towns may still exist, diminished in size and population, or they have virtually disappeared, leaving only a foundation or two, a main street with no buildings, or some homes at a four corners.

For almost 100 years, railroads dominated the economy of Benzie County, and even through the Depression of the 1930s they helped to sustain a comfortable standard of living for area residents. One of the most important features of the railroad in the county was the port in Elberta, out of

which the Ann Arbor Railroad operated a series of railroad car ferries across Lake Michigan. The Ann Arbor car ferries and the people who worked on them kept the freight moving through the county year-round for 90 years and so became an integral part of the community's social fabric and self-identification. Wives preparing dinner in Elberta knew when to put the meal on the table, knowing the particular whistle of their husbands' ferries as they entered their slips.

Through the ups and downs of many industries and ventures, the one unfailing source of non-agricultural industry for the Benzie area has been tourism. Some settlements made a successful transition into tourist-centered towns, serving the visitors who came to the area mostly in the summer and fall. Resorts, roadside cabins, family cottages, and hotels sprang up to take advantage of people coming for the recreation to be enjoyed on the rivers and lakes. The railroads that crisscrossed the county and the steamships that plied Lake Michigan were largely engineered to carry freight, but the companies that owned them saw the advantages of transporting passengers to the area and helped to build the tourist industry. Because transportation was so limited, once they arrived those who came stayed for many weeks or the entire season, creating a resort culture that catered to long-term vacationers. When taking a vacation in the family car became the norm, the all-inclusive resort model changed. The new tourist advertisements from this time stated that in Benzie County a person could visit 50 lakes in 50 minutes.

The county, like the rest of the state, has seen much change since the lumber days, and there will always be a lingering nostalgia for the greatness and promise of what was and what could have been. When a person first looks at the picture on the cover and learns of the Royal Frontenac Hotel, the reaction is one of amazement. The Frontenac is lost, as are many of the industries that once supplied the livelihoods of those living in the settlements that have disappeared or remained. But even with the changes, the people who pass through or reside in Benzie enjoy a special bond of being the fortunate ones. The lakes and rivers, the woods and wildlife, the trains and boats, the clubs and organizations, and the small communities and crossroads make for a storied past and combine for a unique sense of place that endures long after the physical reminders have passed from existence.

# One
# Towns and Settlements

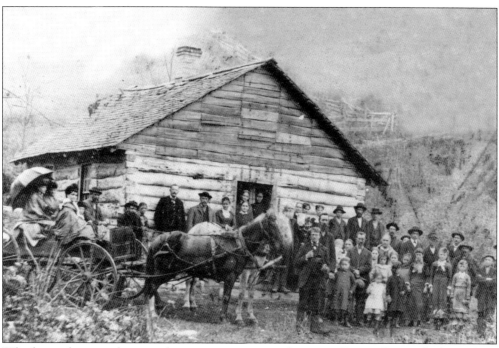

Whether it thrives today or no longer exists, every settlement in Benzie County had one thing in common—timber. And the community participated in the lumber industry, whether it sprang up to cut the trees, move the trunks, or finish the planks. Aral, or Otter Creek, with its residents pictured in front of their schoolhouse and church in 1886, was established by the Bancroft family in the late 1860s.

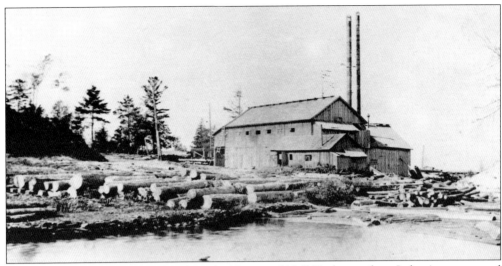

The Hathaway Mill, purchased and run by Norm and Nell Hathaway from Lake Ann, operated from 1901 until in burned down about 1909. From the 1860s through the 1910s, several sawmills were established at Aral, each in turn burning. One of the more infamous mill owners was C.T. Wright, who in an 1890 tax dispute, murdered sheriff's deputy Neil Marshall and Lake Township treasurer Dr. Frank Thurber.

Aral met unusual success as a lumber town and attracted settlers from throughout the state. Pictured at the Aral school are, from left to right, (first row) Francis Bancroft or Gracie Maynard, John Hall, Lowella Bancroft, and Julia Bancroft; (second row) teacher Georgia Norconk (or maybe Katherine Mapes), an unidentified Israelite child, ? Wool, Margaret Hall, May Hall, Vera Bancroft, Pete Hall, and Jonas Hall.

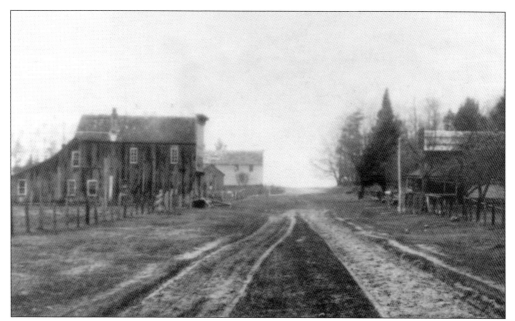

In this 1905 photograph of Esch Road, Aral's main street, is the Hathaway store (foreground, left), previously the Wright store. Farthest down the road is commercial fisherman Pete Rubier's home, which became the bakery for the House of David clan. On the right is the Bancroft store, later the Montgomery store, and eventually the woman's dormitory for the House of David.

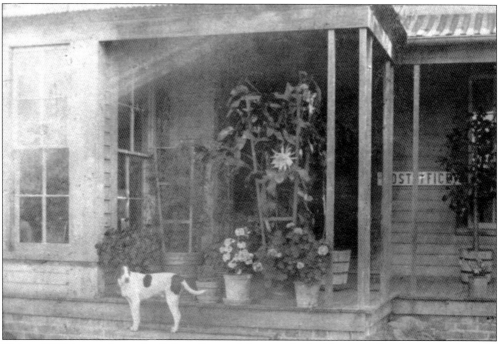

This c. 1900 image shows the Robert Bancroft home, which, like many first homes in the area, also served as the region's first general store and post office. In addition to Jack the dog, the photograph shows the famous night-blooming cereus, which became an attraction that drew people from all around the county.

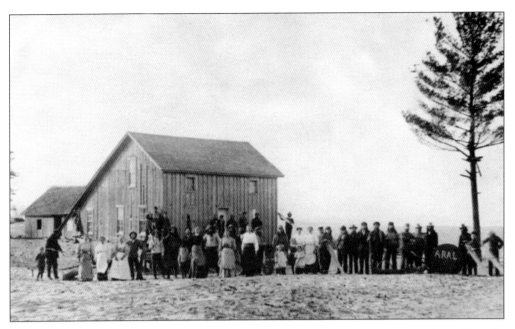

About the time timber began playing out in 1908, a colony of the Israelite House of David bought most of Aral's homes and farms and operated a lumber mill. The buildings used by the Israelites included Pete Rubier's family home (above) and the Montgomery General Store (below). Dedicated to celibacy, vegetarianism, nonviolence, and equal rights for women, the men wore full beards and long, plaited hair. The Israelites were considered different, but cheerful, and were called "Holy Rollers" by locals. They are remembered today for their famous championship baseball teams. When the sawmill became unsustainable, the group tried to rely on farming, but this proved unsuccessful. As usually happened to mill communities that failed to transition to another economic base, the buildings were sold and dismantled, and the last residents left Aral in 1922.

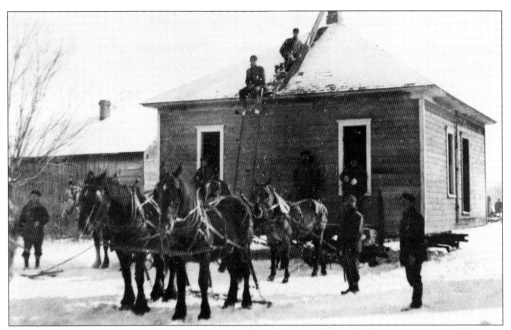

Averytown, named for Avery Thomas, started with a sawmill in the late 1890s. As mill towns go, it was exceptional because, unlike most company towns with slapped-together shelters, the people of Averytown lived in carpenter-built homes with planed lumber for floors and painted siding; some interiors were even wallpapered. When the town was disassembled in the 1910s, the well-constructed houses were moved.

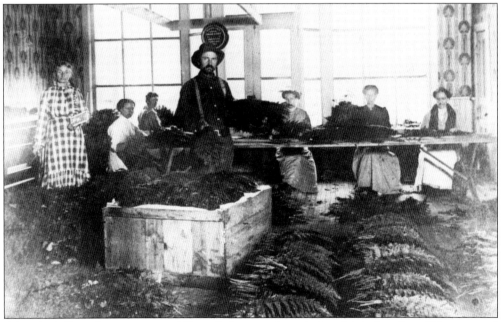

After the hills and swamps around Platte Lake were cleared of useful timber, Dave Waterson and his family did a good business collecting and packaging wood ferns that were shipped by railroad to Chicago for use in floral shops. In this picture, they are processing the ferns in either an old store or post office, which had wallpaper.

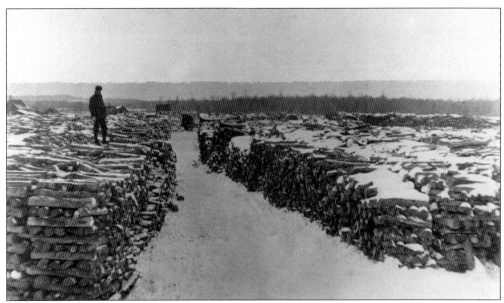

On Carter Creek, a tributary to the Platte River, the small logging community of Carter Siding was established five railroad miles southeast of Honor. It was too small for a post office or depot, but it did have a school. Most importantly, it was the site of the Desmond Chemical Plant, which turned timber from its vast wood lots into charcoal, industrial alcohol, turpentine, and acetates.

Prosperity was available for anyone willing to come to the settlements that grew up along the rivers, creeks, and railroad lines. This was especially true at Carter Siding because of the chemical plant, where a finely attired family poses for a photograph along Carter Creek. Substantial wealth, generated by the non-lumber use of timber products, was sustained here for longer than at the average mill town.

In addition to housing, company towns also meant company stores, like this substantial building at Carter Siding that was owned by Frank Desmond, founder of the town and the chemical plant. Any supplies, such as food, clothing, or farming equipment, could conveniently be put on a tab at the company store, with the amount then deducted from the workers' paychecks.

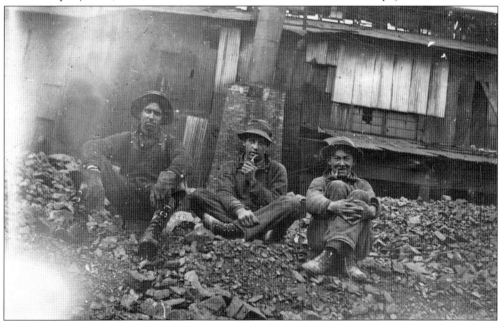

The Desmond Chemical Plant's retort building is pictured with several workers sitting in front. It is in this building that wood was turned into charcoal. During World War I, the plant flourished when the US government purchased as many of the plant's products as could be produced for the war effort.

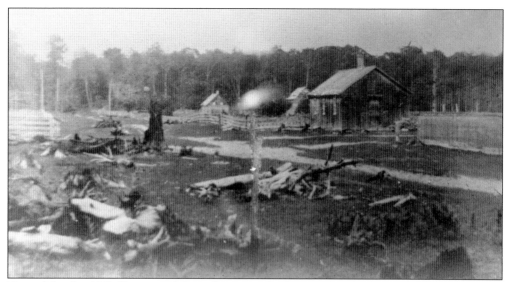

Named for the 1862 Homestead Act, the town also known as Centerville was designated by the post office as Homestead in 1864. In 1877, it contained two sawmills, a gristmill, and a shingle factory. A photograph from the 1870s shows the town's first church among the stumps of clear-cut fields.

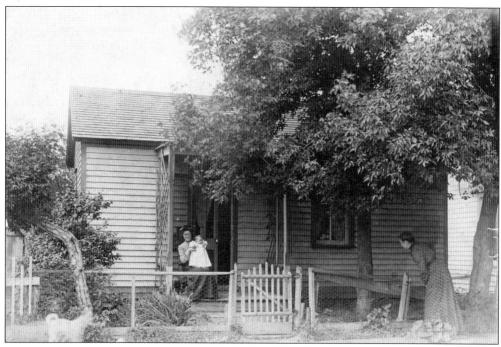

Appropriately named Homestead, both the town and township grew with the Homestead Act. Much of Benzie County was settled by Civil War veterans who received land grants, some drawn by its strong pro-Union and Congregational Church ethics. This home, believed to be the Edgar Case house, demonstrates the prosperity. Homestead's post office was decommissioned in 1903.

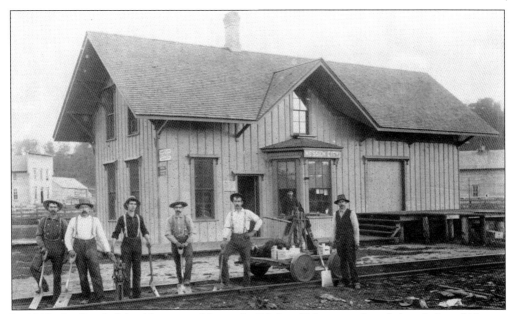

In 1889, the Swede John Nessen and his wife, Edith, of Manistee, founded and platted Nessen City. One of the last lumber barons of the era, he built the mill, was the postmaster, and ran the store. But unlike many of the other ghost towns of the county, Nessen City had a coveted depot on the Manistee & Northeastern Railroad (M&NE).

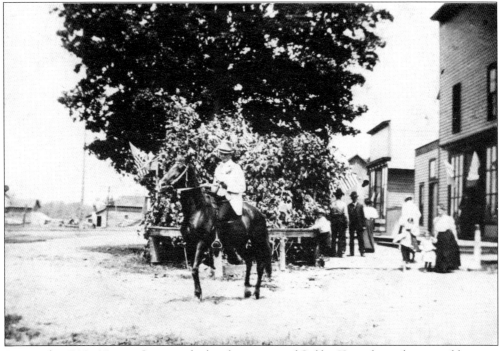

During the 1890s, Nessen City was the bustling center of Colfax Township, when, in addition to millworkers and their families, farmers came to the town for supplies. Pictured here is a Fourth of July celebration in its heyday. The building in the foreground is the H.W. Wilkins store, operated by Henry Wilkins from 1900 until 1911, with the post office building next to the empty lot.

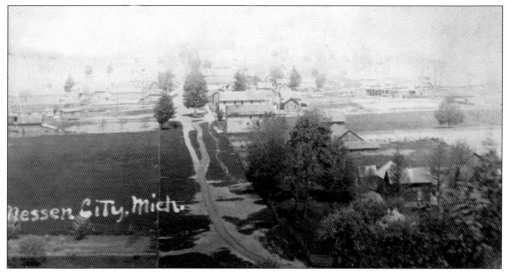

The Nessen City Mill (middle right) is seen on Peppermint Creek along the railroad line a few blocks away from Colfax Street. The town was built about a mile and a half southwest of the old stagecoach stop known as Griner Station and its post office, Print. Nessen City had a 29-room hostelry, a saloon, a livery stable, a Maccabees Hall, and a boardinghouse.

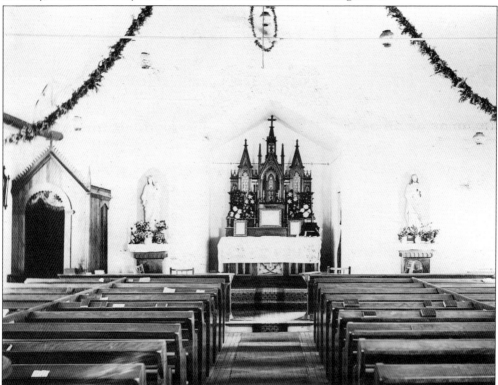

In addition to a two-story schoolhouse, Nessen City had one of Benzie County's two Catholic churches, Holy Family. The church building was erected in 1890 and served by its first resident pastor in 1895, soon after which a large residence with meeting halls was built. The church was used until it burned in the 1920s or 1930s, and parishioners then attended St. Raphael in Copemish.

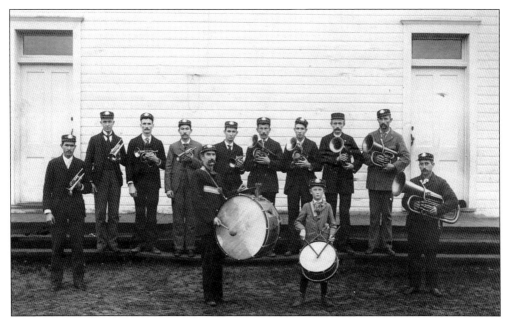

Through the 1910s, Nessen City and its industries remained a large enough town to sustain a civic band. As one species of tree played out, a mill often sold to a company utilizing another species. In this way, a hame factory opened after other hardwoods were exhausted, utilizing rock elm for harness making. The elm was rough cut and cured in Nessen City before being shipped to Cincinnati.

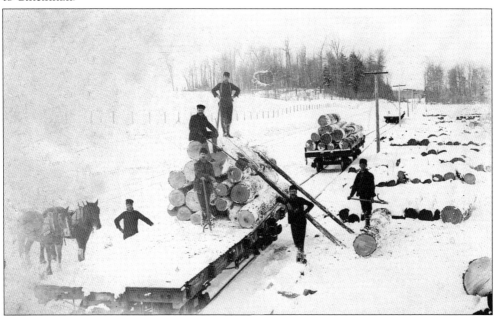

Loggers load timber onto flatbed cars near Nessen City. A chain and cant hook were the means used to load the trunks; in the bottom right of the image, a man holds one, and in the center, a man leans on one. Since Nessen City was founded later than most lumber towns, the mill sawed mostly hardwoods instead of pine. The shingle mill would take advantage of the area's swamp-grown cedar.

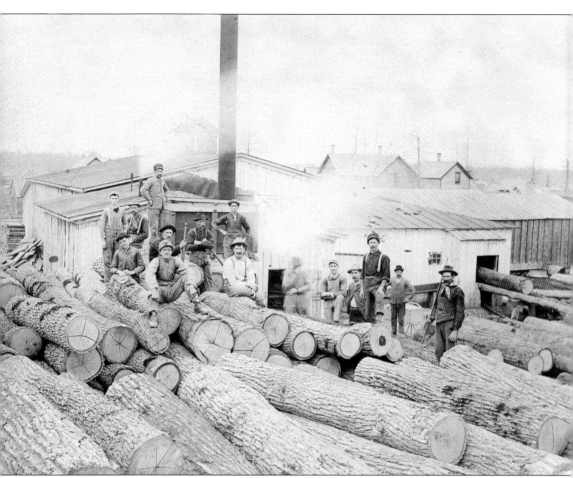

Yards of hardwood are seen stacked outside the Nessen City sawmill to be rolled onto the conveyor and through the log door, seen in the lower right. Nessen City slowly declined in relation to the growth of the major railroad junction less than three miles away to the west, Thompsonville, and because of a series of fires in 1897, 1903, and 1908. The mill closed in 1914, with the last loads being skidded to the saws over an early May snowpack. The building was sold, used as a pickle station, and finally as a warehouse. By the 1930s, little was left, and the Nessen City post office closed in 1933.

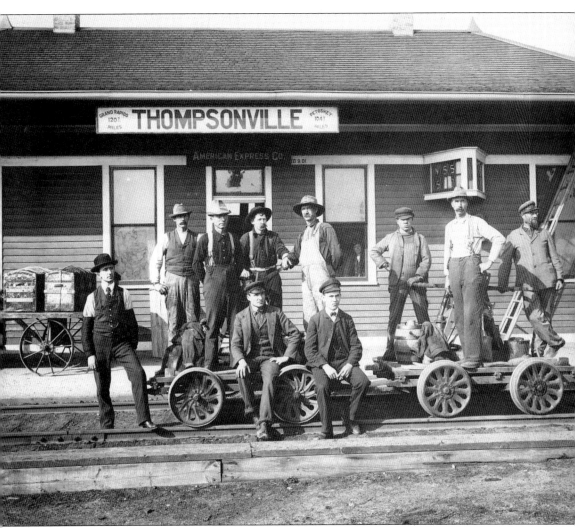

Sitting on the line dividing Colfax and Weldon Townships, Thompsonville still exists but pales in comparison to what it was at the start of the 20th century. Platted in 1890 by the recently widowed Sumner Thompson of Vermont, the town's foundation is the result of her company, the Thompson Lumber Company. However, its marked growth came in 1894 with the "diamond," the junction of the two major railroads of northwest Michigan. The line crews of both the Ann Arbor Railroad and the Pere Marquette Railway (PM) are seen posing in front of the Pere Marquette depot, along with the car inspector of the Pere Marquette.

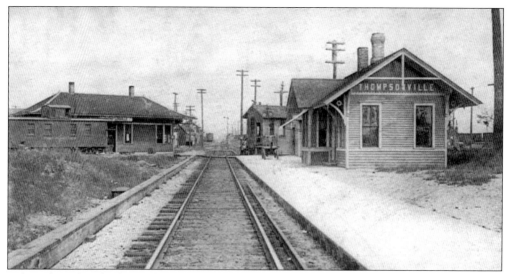

When the railroads chose Thompsonville as their junction, it was agreed that the last to reach Thompsonville would assume the expense of building and maintaining the diamond. The Ann Arbor, whose depot is on the right, lost the race. Saloons, hotels, and businesses soon abounded at this important and busy Michigan crossroads.

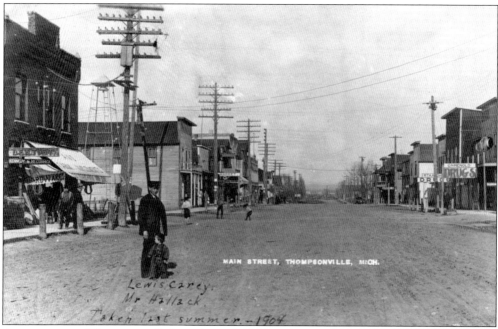

A street scene of Thompsonville from the early 1900s indicates the wide boulevard and the many shops brought by railroad commerce. Anything traveling in or through northwest Michigan had to pass through Thompsonville. The Pere Marquette Railway ran south to Chicago and north to Petoskey. The Ann Arbor connected Toledo to Frankfort, and in Frankfort the railroad operated the ferries hauling goods across Lake Michigan.

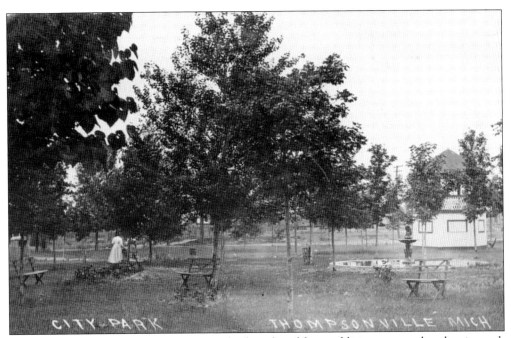

A source of civic pride and a conspicuous display of wealth, in addition to a gazebo, the city park also boasted a fountain. It would be the gathering spot for the city's civic gatherings and the Thompsonville Fair, which attracted up to 7,000 people a day for the three-day event.

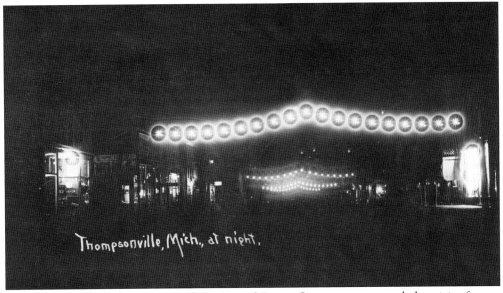

Already in 1895, the Thompsonville Light and Power Company generated electricity from a coal burner—free of charge for the city's residents. Having gained a reputation for the best-lit city in Northern Michigan, street lighting took the unusual form of strings of lights across the streets. In 1903, the Thompsonville Dam was built to accommodate the town's growth and need for electricity.

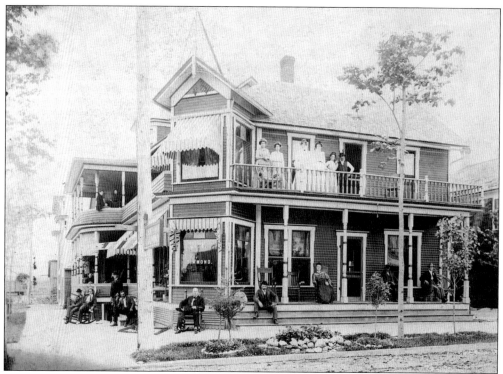

The very busy commercial town had a number of hotels; the most famous and one of Michigan's finest, the Diamond House (above), was owned by Ella Diamond, a young widow from St. Charles, Michigan. Well appointed, it boasted a Chinese laundry, complete with Chinese workers. Built in 1895, and then rebuilt after a 1902 fire, it stood until it burned for the last time in 1928. The fineness of the Diamond House (below) is attested to by its dining room set for Christmas. The wallpaper, mirror reflecting the set table, paintings, and electric lights indicate the elegance of the hotel.

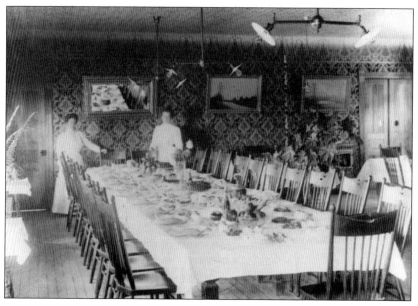

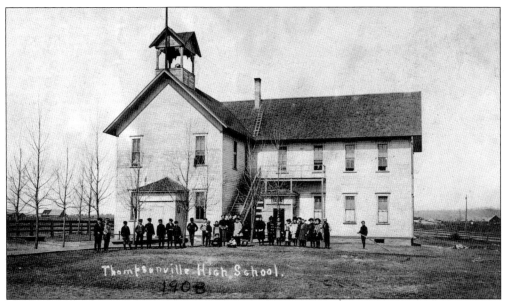

Thompsonville School, built in 1891, had two teachers and an initial enrollment of 86 students. Over the next decade, additions were built as the student population, and number of teachers, increased. It drew students from neighboring communities, because it was one of the few to extend classes to 12 grades. The building burned and was replaced in 1924.

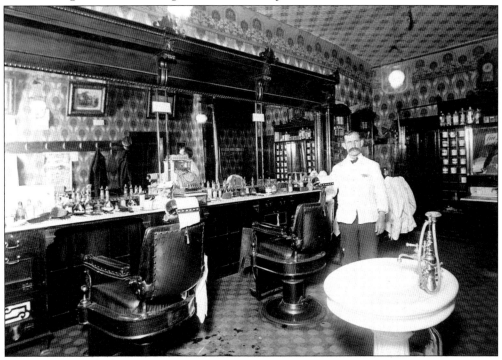

One of Thompsonville's great businessmen, Julius Hale, is pictured in his combination barbershop and poolroom, complete with wallpapered ceiling. It was said that he was always on the lookout for a business opportunity. Before the bank opened, Hale would cash a person's check for a small fee. He went on to be the county's first Ford dealer.

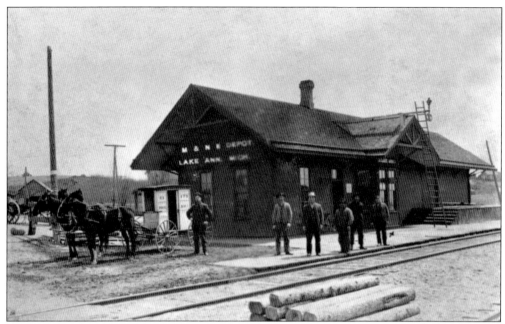

Lake Ann, the lumber town still existing on the shores of the lake with the same name, was established in the early 1890s by the Manistee & Northeastern Railroad. It moved its depot from Ransomville, on the south shore of the lake, to the north shore due to a right-of-way dispute with Elijah Ransom.

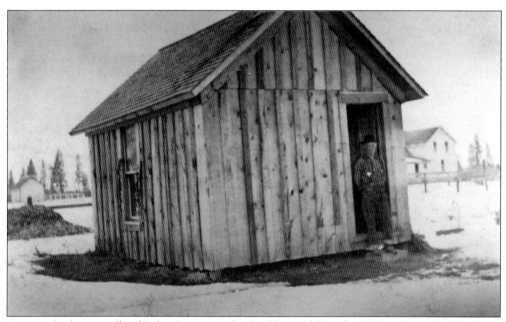

Among the larger mills of Lake Ann were the Buckley and Douglas Mill and the Habbler Mill. Because of the sometimes rough trade among the lumberjacks who came to town for supplies and drinking, even small towns needed a jail, such as this one at Lake Ann with the constable standing in the door.

Merris Sherman stands in front of his shingle mill in Lake Ann. Since wooden shingles frequently needed to be replaced, cutting shingles was always a steady business, especially if a person had a steam engine. But when the roofs of entire towns and villages were shingled with wood, fire was a constant hazard.

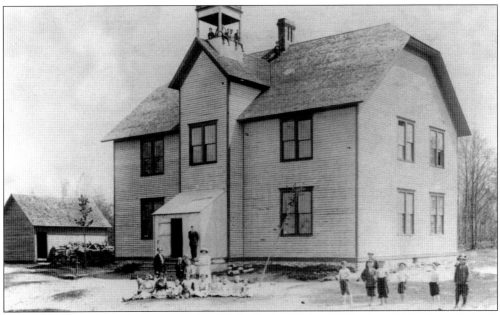

Lake Ann suffered several disastrous fires, with the first in July 1897, after which many residents left. One of the buildings to survive that fire was the schoolhouse, which had graduated its first class a month before. After surviving other Lake Ann fires, the school building was dismantled by the Works Progress Administration (WPA) in the late 1930s and its materials used to build the Lake Ann Town Hall.

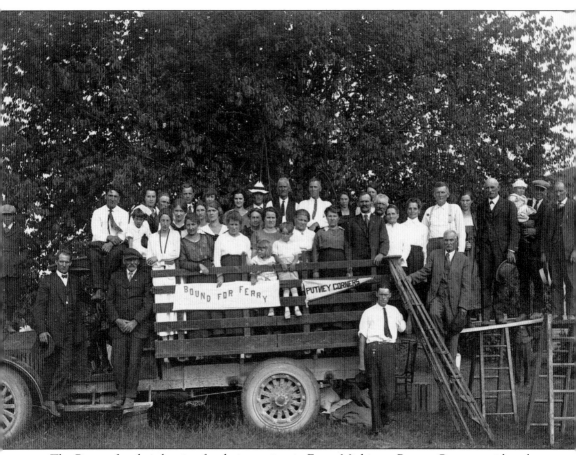

The Putney family is leaving for their reunion in Ferry, Michigan. Putney Corners, with only a school and general store, typified the sparse settlements of Joyfield and Blaine Townships. After the timber was harvested, no major mill, factory, or railroad merited a village or depot; instead, orchards and fruit processing became the dominant industry. Joyfield Township was named for Amariah Joy, a Baptist minister from Maine, who arrived in 1863. His son William was a highly commended Union soldier during the Civil War. William Joy wrote of the township in 1897: "The vast forest that covered the township in 1863 has mostly disappeared, and in its place we see farms and large clearings, good buildings and fine orchards. Joyfield is destined to be one of the best, if not the best, township in the county."

Maple trees brought Joseph Gifford, an English industrialist, to the Platte River Valley. He was the head of the Guelph Patent Cask Company, and the ready supply of high-quality hardwoods was the key ingredient to the wood containers his company manufactured. In 1895, he bought property along the Platte River and laid out the village, naming it for his daughter Honor.

The Pere Marquette Railway extended a spur from Turtle Lake, and the first shipment of freight to Honor was the equipment for the new lumber mill. Around 1900, the Manistee & Northeastern, building on its success at Lake Ann, also built a spur as well as a depot to add passenger service to Honor.

Honor Gifford 1894 – 1923.

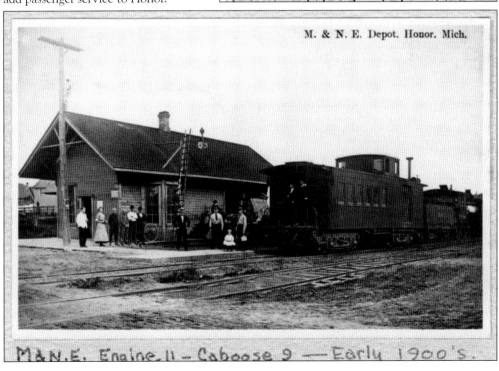

M&N.E. Engine 11 – Caboose 9 — Early 1900's.

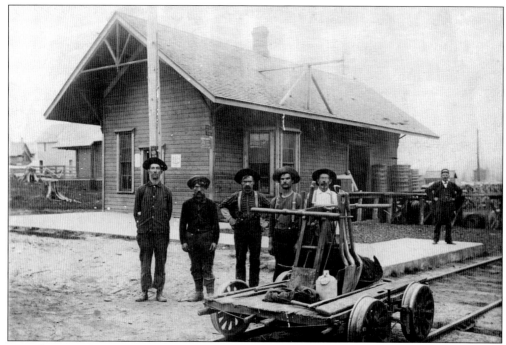

From left to right are Ralph Hooker, Guy Parker, Joe McCarthy, George Pierce, and Chancy Brace, the M&NE's line crew, posing in front of the depot with their handcart full of shovels and picks. A railroad depot served multiple functions. In addition to selling tickets and providing shelter for passengers, postal telegraph services, such as making and cashing money orders and travelers checks, were offered.

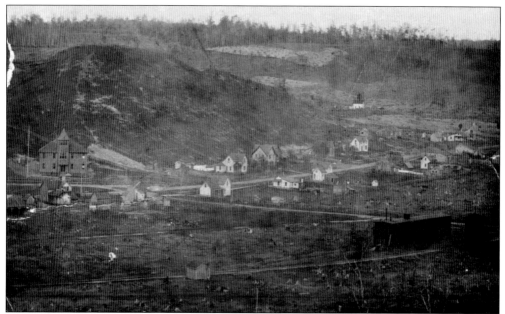

A view of the Platte River Valley and the town of Honor shows the Pere Marquette railroad line, with a coal station (foreground right) and the Honor schoolhouse (far left). The large mill was placed along the river, just out of the picture, with its log yard extended to both sides of the Platte.

With its central location, Honor served as the county seat between 1908 and 1918, having taken the baton from Frankfort and handing it off to Beulah. In this brief time, memorable county-wide festivals and fairs were hosted by the townspeople, including one of the last large Grand Army of the Republic (GAR) encampments for Civil War veterans as well as remarkable Fourth of July celebrations. For years, people spoke of the balloon ascension, at right. Other festivals included the Hog Days, a precursor to the county fair. Below, a stage is set up in front of the Brundage Hotel for speeches and performances.

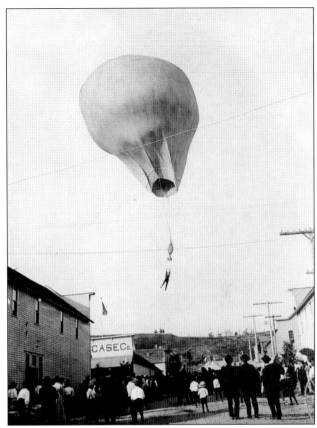

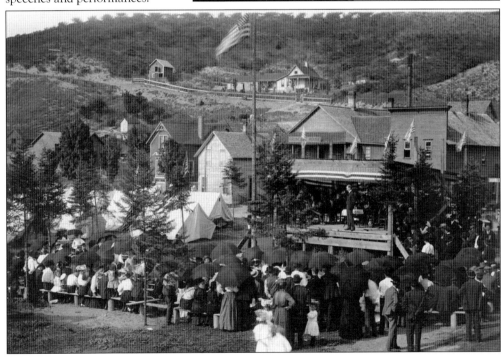

When the lumber mills began to slow down or close, it became apparent to those living on the eastern side of the county that their soil was particularly fertile for growing cucumbers used to make pickles. With the railroad tracks already laid and the sidings built at the lumberyards, many of the old mills were converted into pickle-packing and -shipping stations.

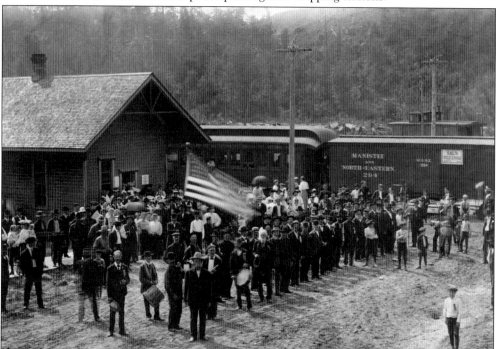

A celebration takes place at the Manistee & Northeastern depot. The occasion is lost to history, but it was probably a reception for the veterans of the GAR, who had a massive encampment in the outskirts of the city. Noteworthy in the picture is the Manistee & Northeastern boxcar labeled, "Salt," as Manistee was known at this time as "Salt City" for its production of the mineral.

# Two
# BUSINESSES

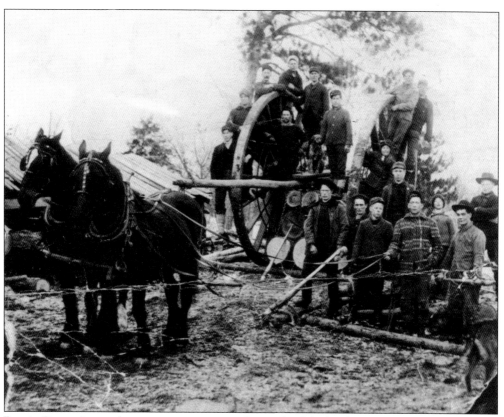

Benzie County's initial economic success was the result of the lumber industry. Big wheels, such as the one pictured here, were commonly seen throughout the forests and used to drag the logs to the rivers and railroad sidings. The lumberjack crew includes a young Roy Tower (front row, third from the left), who later identified and cataloged many of the early photographs and artifacts given to the Benzie Area Historical Society.

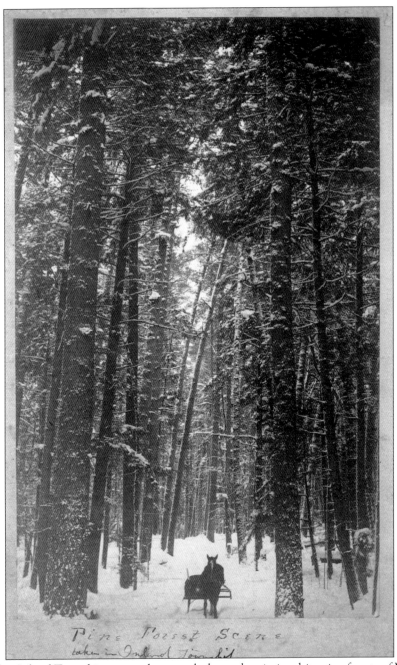

Captured in Inland Township, a rare photograph shows the virgin white pine forests of Michigan. It illustrates the great wealth to be had for those who worked to harvest, cut, transport, and process timber for the growing cities of the Midwest. White pines could grow to over 100 feet tall and up to eight feet in diameter, with each tree yielding hundreds of board feet of lumber. Famed more for its hardwoods, Benzie County also contained concentrated stands of the white pines. After the white pine was harvested for lumber, hardwoods like maple and oak were taken from the loamy woods for barrels and furniture, rock elms for harness making, hemlock for tanning, and finally cedars were taken from the swamps for shingles and posts.

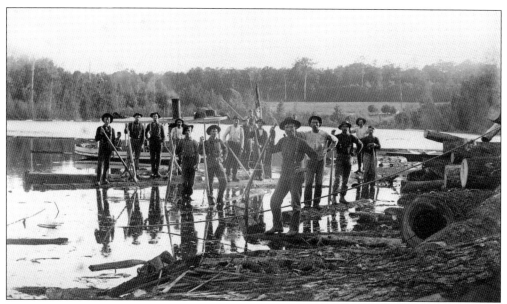

Even after the arrival of railroads, creeks and rivers were the most convenient way to transport felled timber. Ideally, the waterway would lead to a sawmill's pond, such as the Habbler Heading Mill at Lake Ann, with a steam tug helping the drive. Wearing specially spiked boots and using cant hooks and peaveys, river drivers would ride the logs to keep them from jamming.

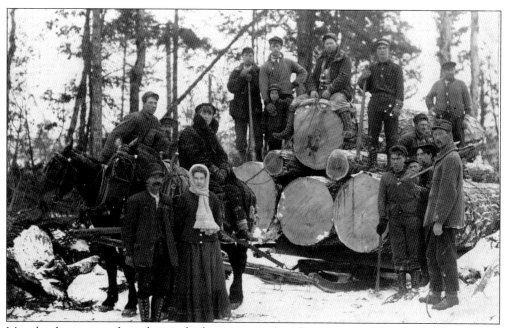

Most lumbering was done during the long winter when farming stopped, migrant labor arrived for the work, and the timber could be easily moved to the riverbanks or railroad sidings with logging sleds. Pictured at the lower left are Mr. and Mrs. George Hawkins, who are lumbering on their Joyfield Township property in the Upper Herring Lake Swamp.

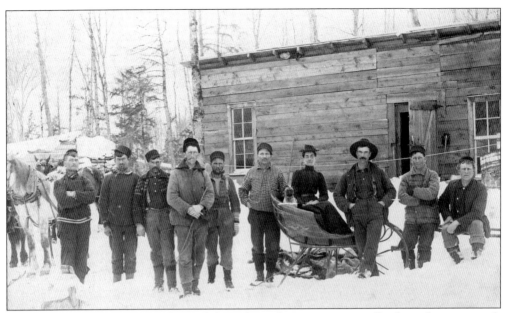

Temporary logging camps were located throughout the county, especially along the rivers, such as this one from 1894 on the Betsie River in Benzonia Township. From left to right are two unidentified, Fred Covel, Boyd Barker (with a pipe and stick), unidentified, Walter Berry, Mattie Berry, John Bailey (leaning on the sled), and two unidentified.

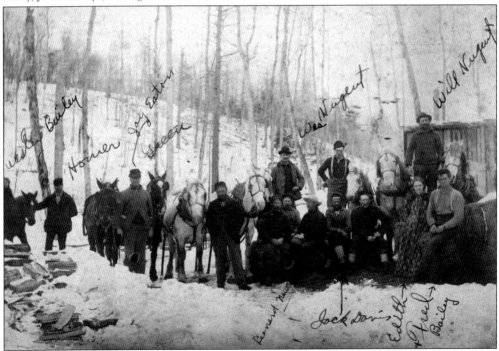

Another camp, this one near Bellows Siding in the western part of the county, shows, from left to right, (first row) Wesley Bailey, ? Hower, Jay Eaton, three unidentified, Bernard Newkirk (sitting, white hat), Jack Davis, unidentified, Edith Bailey (cook), and Fred Bailey (foreman); (second row, standing) Wes Nugent, unidentified, and Will Nugent.

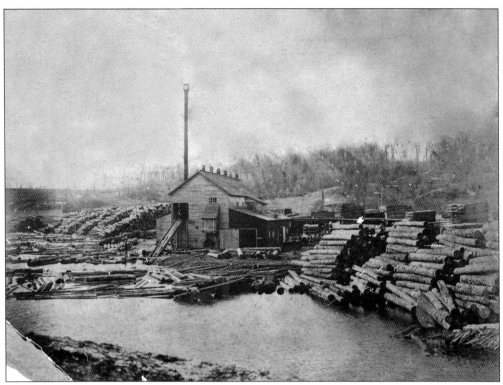

Over the course of winter, logs were stacked along the waterways waiting for the spring thaw and the snowmelt, which meant higher water levels for easier transport. Above, logs are stacked this way at Case's millpond off Cold Creek in Benzonia Township. With high water, the logs were rolled down the bank to the river or pond or were dragged to the water by horse or oxen teams to be floated easily to the mill. Below is a larger view of the operation of Case's Mill that shows the logs stacked near the slightly frozen pond, the mill with the ramp into the saws, and the stacked lumber awaiting pickup near the railroad tracks.

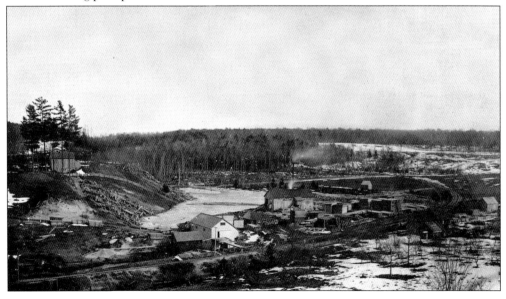

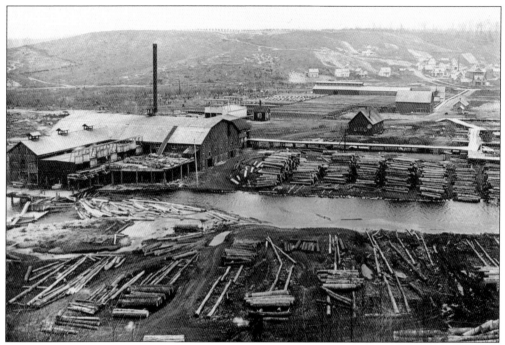

Plank lumber was not the only wood product manufactured by Benzie County's many timber processors. Shown in the upper right corner of the photograph, the village of Honor rests in the Platte River Valley, sitting below the hills denuded of trees. The Guelph-Patent Cask Company in Honor, whose log yard spanned both sides of the Platte River, turned hardwoods into containers.

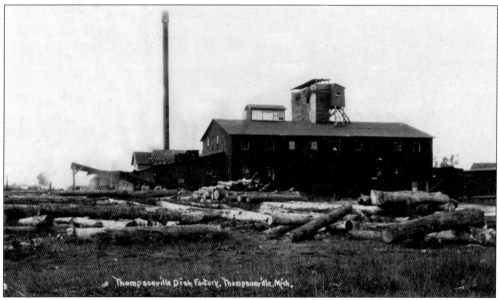

In Thompsonville, the Oval Wood Dish Factory, or Butterdish Factory, sits between the tracks of the Ann Arbor Railroads and Pere Marquette Railway. It employed about 14 women and several men. At this plant, timber was steamed, rolled, and turned into assorted sizes of packing bowls for shortening, butter, lard, and ground meat.

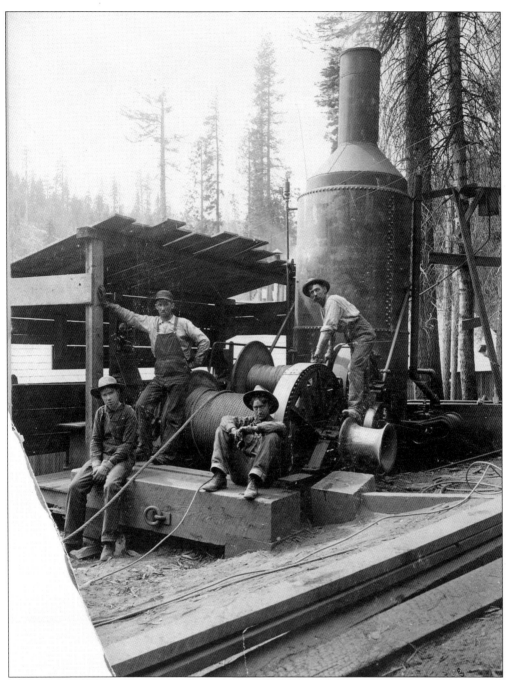

A steam engine that operated a winch, known a "bull donkey" engine, is pictured in Elberta. Steam was the power that drove the engines of Benzie County. Saws, farm tractors, ships, locomotives, and any other device that needed to move, or to move something else, harnessed the power of steam. To produce it, some form of carbon was burned, and the cheap and ready source of fuel in Benzie County was wood. Some individuals made their living simply chopping wood and hauling it to the companies that used it for their engines, in some cases loading boats and delivering it to steamships in transit on the Great Lakes.

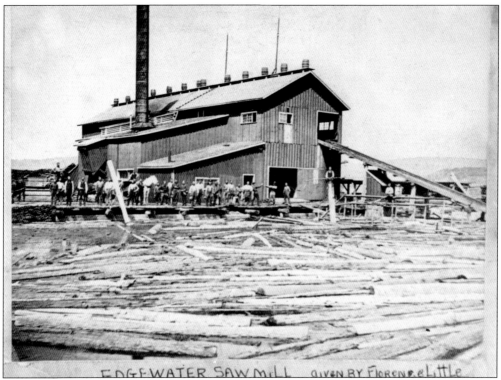

The Edgewater Sawmill was unique in the area in how it used three bodies of water for its operations: the Platte River, Platte Lake, and Lake Michigan. The Platte River's branches provided cheap and easy transportation for the lumber camps in most of the central and northern parts of the county. The river ran into Platte Lake, which Edgewater Sawmill used as its millpond. Sitting on the lake's northwest shore, the sawmill also had easy access to nearby Lake Michigan. The sawmill, seen above with water barrels on the roof for fire protection, provided livelihoods for the many workers and their families, as shown below. The population at the Edgewater sawmill rivaled that of some of the area's new towns and even had a school.

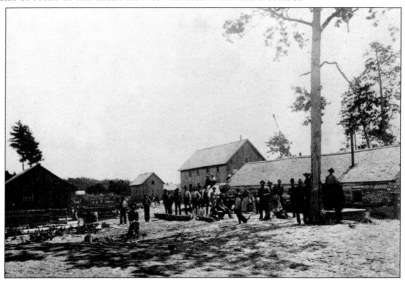

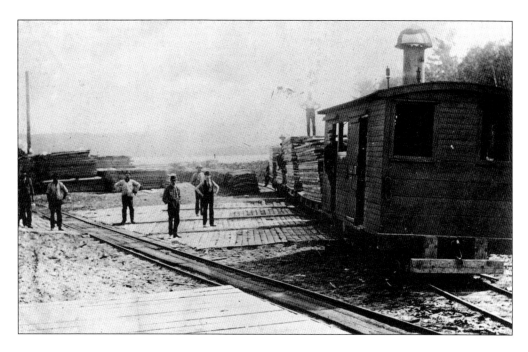

Above, a boxcar has been converted into a steam engine with a chain drive to move the milled timber along a narrow-gauge track laid by the mill. The track extended from the mill on Platte Lake into Lake Michigan via a pier, where the product could be loaded directly onto a lumber hooker, which was a steamship specially fitted for transporting lumber. Below, the appropriately named lumber hooker *Frank Woods* takes on a load; the unique boxcar engine, with the smokestack rising from the middle, appears on the far right side. When the mill closed, the track was taken up, moved to Carter Siding, and used by the Desmond Chemical Plant.

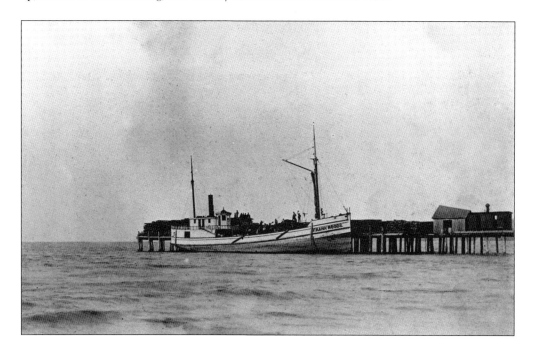

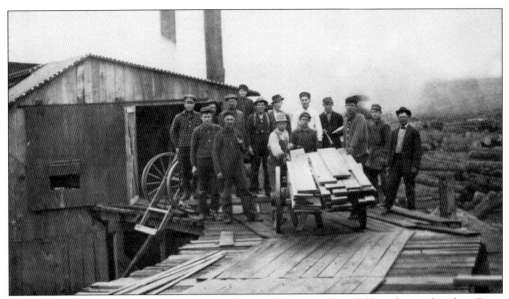

Large or small, steam mills, such as Dair's Mill in Weldon Township, followed a similar plan. From the millpond, which made the logs both easier to move and cleaned them of grit, the logs were pulled up an incline by a continuous chain, known as the bull chain, into the mill's second story. Inside, they were secured to a carriage, which moved them to the large circular saws powered by the ground-level engine. After the initial cut, the boards moved to an edger, which squared them by removing the bark and cutting the logs into the desired widths. The leftover edging was then cut by a slab saw into lengths used for boilers, furnaces, kitchen stoves, and fireplaces. Below, the finished planks were loaded onto a two-wheel cart and wheeled down the elevated platform, or tramway, where the planks were "stickered" (stacked for ventilation and quicker drying).

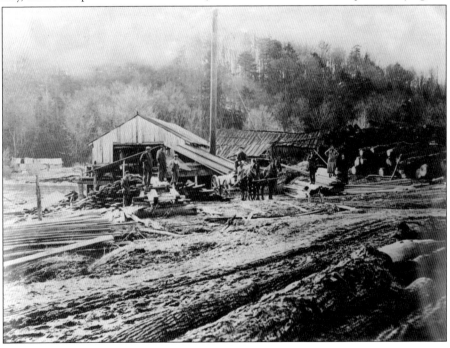

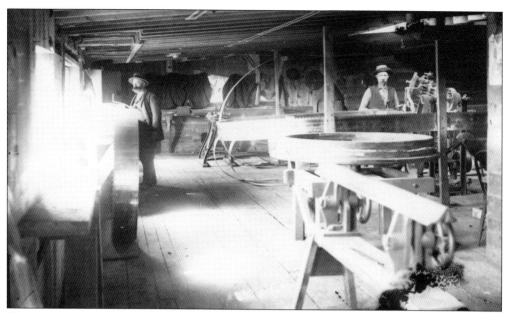

Working inside a mill, such as these in Frankfort, usually meant a 10- to 14-hour day with competitive wages. The lumber companies and what they manufactured may have quickly come and gone, but as long as the timber stood, work could always be had in a mill or factory for both men and women. By modern standards, the work was very dangerous because of the exposed belts, turning wheels, whizzing blades, exploding boilers, and inevitable fires. In factories where the process called for the wood to be steamed or boiled, open vats of boiling water took lives. In spite of the hazards, people sought mill jobs for the dependable paycheck, and many saw the work as an improvement over the even more unpredictable life of a farmer.

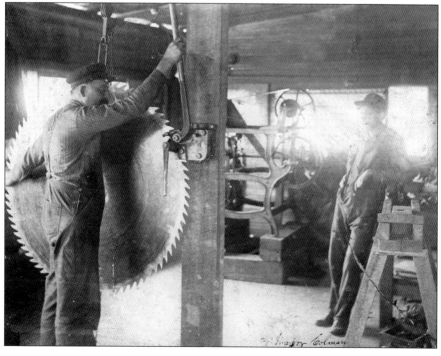

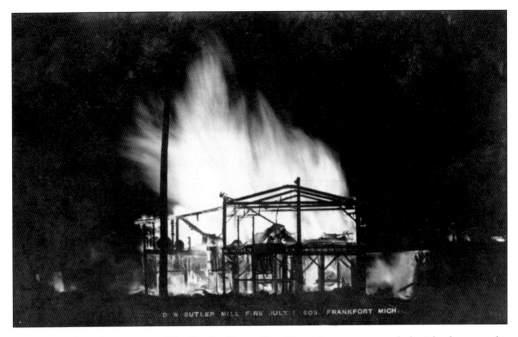

The fire and smoking ruins of the Butler Sawmill in Frankfort were recorded with photographs on July 1, 1908. The remnants of the boiler and machinery from the ground floor are seen, with the smokestack leaning on the drivers that powered the saws on the second floor. Even mills that survived well into the twentieth century to be dismantled or converted to other uses had been rebuilt several times over. With the combustible wood and chemical products manufactured by the mills, the explosive products used to treat the wood, the flammable byproducts (such as sawdust), and the too-often exploding boilers used to make the steam, fire was an ever-present danger and a common fate.

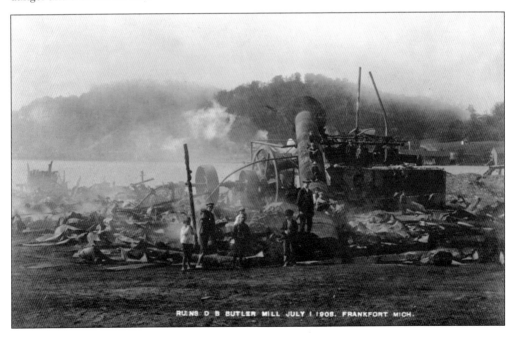

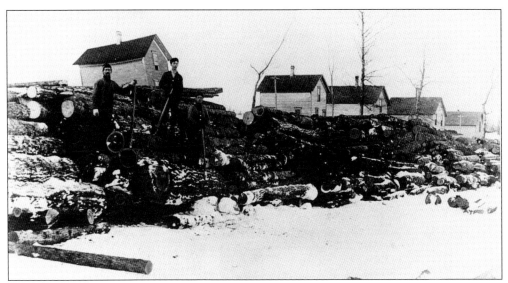

In 1890, Leo F. Hale started a lumber company on Lower Herring Lake in Blaine Township. By 1892, the camp on the south shore of the lake, complete with stores and post office, was incorporated as the village of Watervale. Ernie Gilbert (center) and Dan Campbell (right) stand upon their log pile on the shore of Lower Herring Lake, with some of the camp's homes and buildings behind them.

After the lumber activities ceased, most of the homes were abandoned. However, rather than being dismantled, the property and buildings were purchased by Oscar Kraft in 1916 to be used as a summer camp for his large family. With other family members involved, the old lumber village turned into the lake's first resort, with the original offices, cabins, dormitories, and stores used to this day.

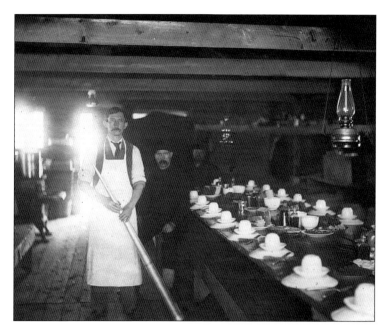

With the table set, a cook prepares to call the lumberjacks to a meal with a horn. The camp cook commanded much respect, with the workers making a point of following the eating hall's rules. Feeding the lumbermen was a herculean task, as the hard work in the cold weather required many calories. The reputation of a lumber baron's company depended on the quality and variety of the food provided.

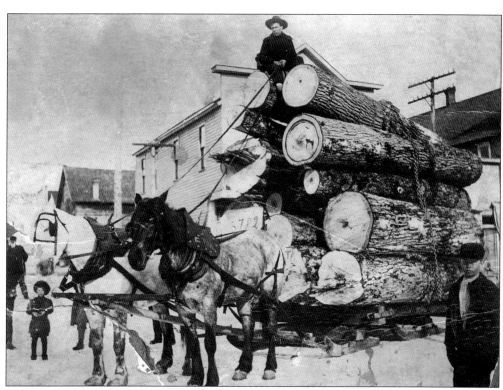

With the number of board feet proudly tacked to the logs stacked on the lumber sled—5,782—Honor's biggest load of lumber is memorialized with a picture. The board feet measurement was taken with a lumber scale, a special measuring rod placed over the log's diameter that indicated how many board feet were contained in it.

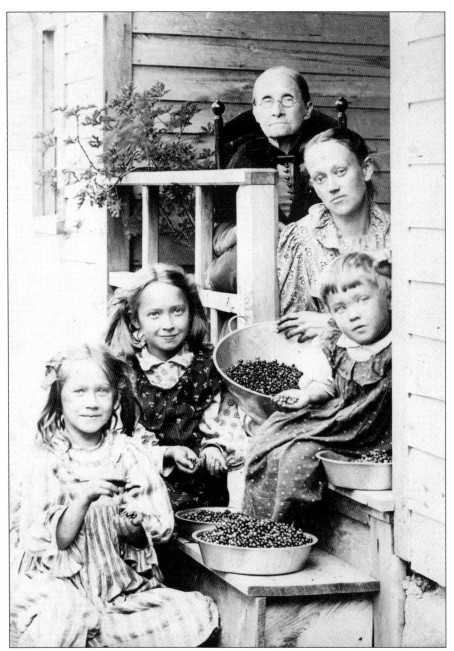

Three generations of the Nutting family pose with their picked blueberries in 1897. From front to back are Jennie, Ruby, Maggie, Mrs. Wallace, and Sarah. With the land cleared of trees, it was natural that the next enterprise be agricultural. Civil War veterans and their families came with land grants to stake homestead claims on the recently clear-cut hills and flatlands; many came from Ohio and New England. They had heard about Benzonia, the county's first town, founded in 1858, which was established by Oberlin College alumni as an abolitionist religious colony. Settlers' letters from the farming townships mention how they chose Benzie County because of the "Oberlin experiment." With their land grants, former soldiers who were consciously fighting to free the slaves could settle among people as dedicated to the cause as they had been.

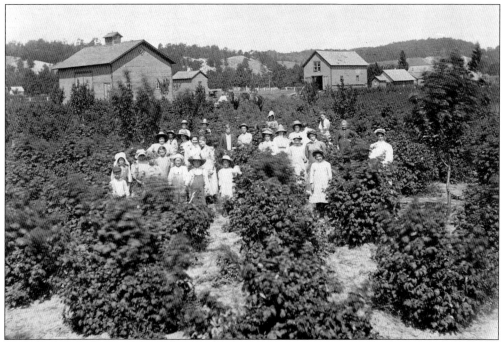

The sandy, acidic soil, once populated with white pines and other conifers, proved very successful for growing blueberries and raspberries. A 1915 picture from the John Westin farm, near Elberta, shows a troupe of raspberry pickers, all with hats and a few exceptionally large bonnets to protect them from the hot July sun.

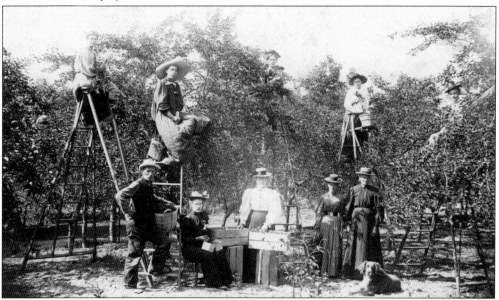

Cherries are another very successful crop in northwest Michigan. The particular three-legged design of cherry picking ladders is displayed, which were being used at an unidentified cherry orchard. Before mechanized tree shakers and sprays used to loosen the stem from the branch, picking cherries was a labor-intensive task. It was also a rite of passage for young people taking a first summer job.

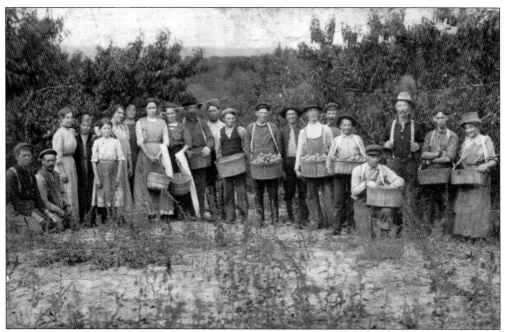

Peaches, along with most other orchard trees threatened by cold, dry winter wind, flourish in the counties abutting Lake Michigan. The "Big Lake," as it is called, moderates the temperature and humidifies the winter air. Workers at either the Paul Rose or Voorheis Orchard fill their strapped-on picking baskets with the late summer fruit.

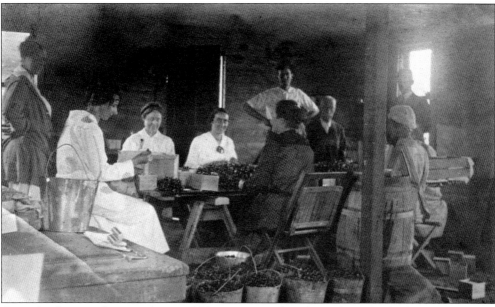

Once the fruit was harvested, it would be transported to the packing shed, where many hands were set to cleaning, sorting, and packaging the fruit. Shown here are, second and third from left, Dorothy Kraker and Jane Rossmore Rogers. The Krakers, whose pies would become a tourist attraction, would go on to become pioneers in the frozen food industry.

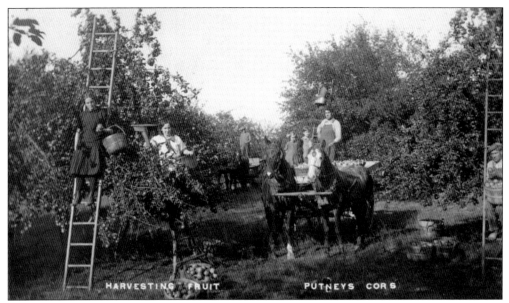

Last to be harvested in the short growing season are apples, shown here as they are picked in Wesley Smeltzer's orchard, near Putney Corners, in the fall of 1914. From left to right are Myrtle Shettler, Mame Smeltzer, Lester Lawrence, Iva Cornell, Stephen Cornell, Clare Cornell, Wesley Smeltzer, and Emil Westergard.

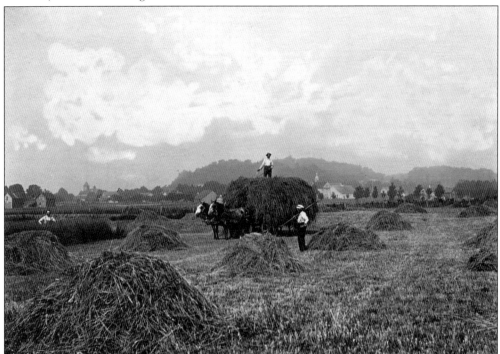

A team of men and horses makes hay in the Jacobsen field outside of Frankfort. The steeple to St. Anne's Catholic Church, silhouetted against the hill, can be made out just to the back of the wagon, as can the steeple of the Congregational church to the far left standing out against the sky.

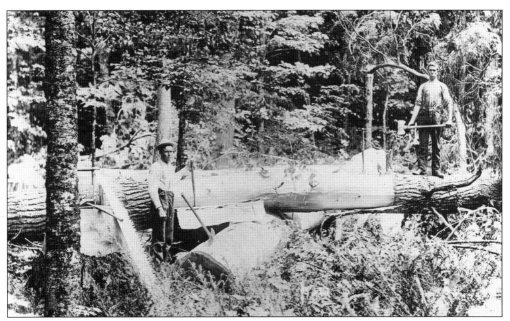

Workers are seen displaying a particular skill in peeling hemlock bark. Hemlock, which was not particularly sought out for lumber, was instead harvested for its bark. The bark, which contains high quantities of tannin, was used by tanneries to turn hide into leather. Favoring swampy areas, hemlock was produced in great quantities in the low-lying land of the county.

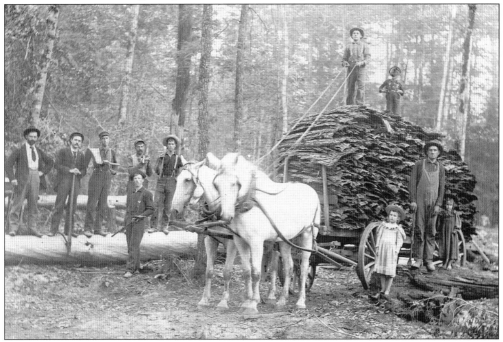

A small work crew, with some members dressed in their Sunday best, poses at a work site near Lake Ann. The man on the right holds a bark spud, used for stripping bark. In contrast to the winter work of lumbering, stripping hemlock was a summer occupation, as the bark had to be dried for a season before it could be shipped.

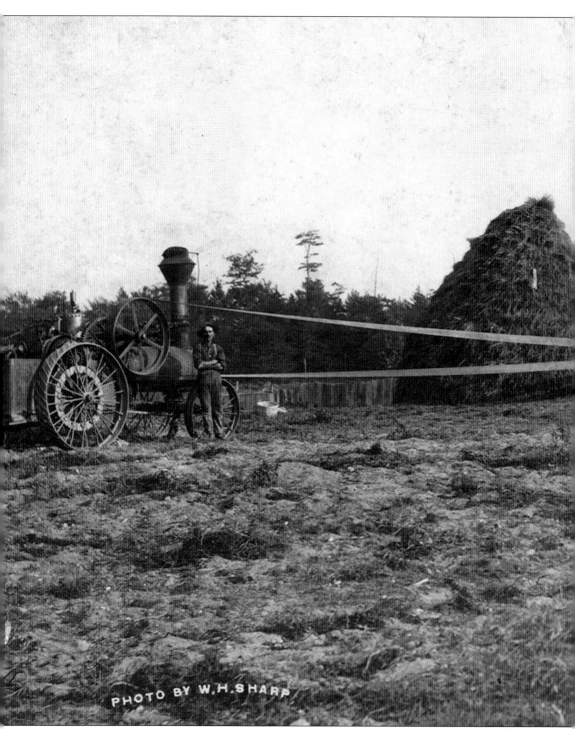

Cliff Keiler (far left) stands with his thrashing outfit in Blaine Township in 1907. If a farmer grew grains, such as wheat, rye, or oats, it would have to be threshed, meaning the seed would need to be separated from the hull. The thresher and his outfit, the equipment and men who ran the equipment, would travel from farm to farm and set up near a supply of fuel or water. The

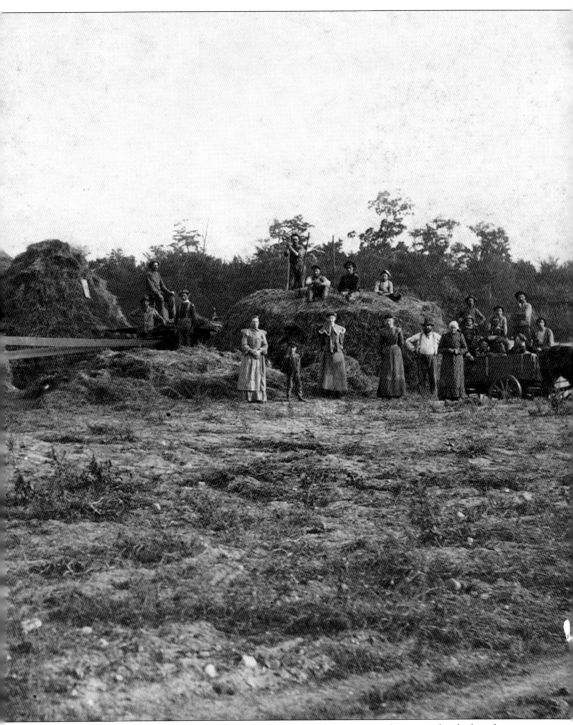

thrasher's outfit was responsible for the operation of the machinery, keeping the fuel and water going for the steam traction engine, while the farmer was responsible for delivering the sheaves and hauling away the grain.

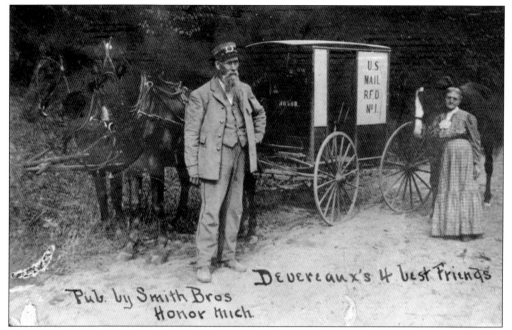

In Honor, the first Rural Free Delivery (RFD) mail carrier, R.W. Deveraux, sent postcards of himself posing with his "4 best friends," three of whom are horses. Unlike city cousins who had mail delivered to their homes twice a day, before RFD people in rural areas had to spend much time and many miles on the road to pick up their mail at a post office.

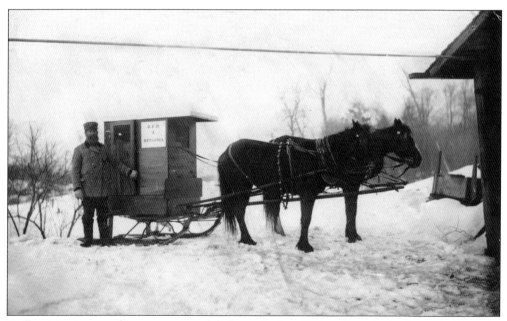

Wallace Nutting, standing next to a mail sled, was the first RFD mail carrier in Benzonia. Begun in the late 1890s, a community had to petition the post office for Rural Free Delivery. A requirement made by the post office was passable roads. This spurred local governments to spend money on road building and improvement.

Nets are seen here drying on the Frankfort docks. Fishing was the first commercial enterprise in Frankfort, begun by one of the city's earliest residents, Joseph Oliver. Soon joined by the Rubiers, Rodals, and Olsens, the work was initially done with sailboats, with the center of operations on the "island," which was actually an isthmus that extended south into Betsie Bay (where the Frontenac would later be built).

Fish tugs, when not used for fishing, were frequently hired out for towing and excursions (hopefully after a good cleaning). The *Gotland*, powered by gasoline, was owned by Bill and Johnny Jacobson and a Mr. Bohnow and used on occasion for pleasure trips. But such boats were also haunted by tragedies, as when Pete Morris drowned in January 1930 while fishing on the *Gotland*.

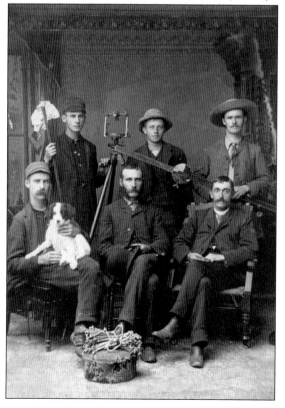

In a photographer's studio, a group of friends poses with the instruments used by a surveying crew, including a transit, a level, and a chain on the stool. They are, from left to right, (first row) Fred Waters, Albert Adams, and John Hubbell; (second row) Jessie Packard, Fred Heath, and unidentified. The first survey of what became Benzie County was done in 1838. The original description of the natural resources done by the surveyors did not contain many compliments, as the quality of the soil and the climate was not conducive to mid-19th-century farming. Ironically, it was the poor quality of timber and soil around the county's many lakes that made the land a poor bargain for a settler.

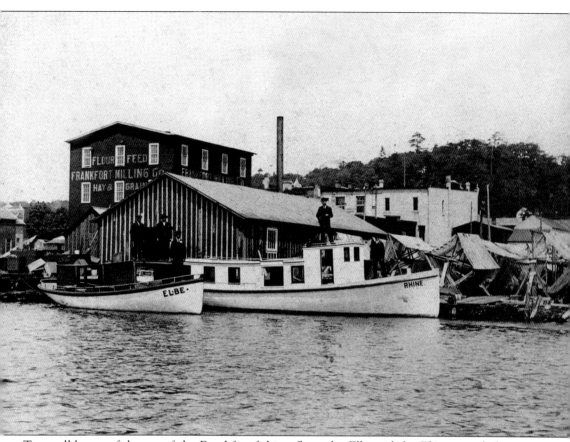

Two well-known fish tugs of the Frankfort fishing fleet, the *Elbe* and the *Rhine*, stand along Frankfort's fishing docks. The gillnets were repaired after the morning run and are seen drying to the right of the *Rhine*. Always at risk, those who fished on Lake Michigan were in danger of death and injury caused by the hazards of the occupation and the sudden changes of weather on the lake. The *Elbe* and *Rhine* were owned by German immigrant Henry Hanrath. He and three other crew would drown returning from a fishing trip on Christmas Eve after the *Rhine* smashed into the Frankfort pier. Only two of the three bodies were recovered for burial.

Rodal Fisheries was located along the wharf on Betsie Bay at Waterfront and Third Streets. Among the oldest of Frankfort's fishing companies, it was owned and operated by Louis Rodal. One of their fishing tugs was the *Francis C*. Rodal's sons Otto and Ludwig would also join him in the company.

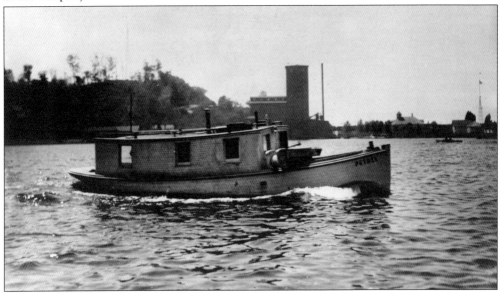

Beginning with other fisherman in the 1870s with a sailboat, Louis Rodal would end with a fleet of tugs, including the *Petrel*. Fishing tugs were one of the most versatile forms of transportation around Betsie Bay and could be found doing all types of work in all seasons, including hauling freight.

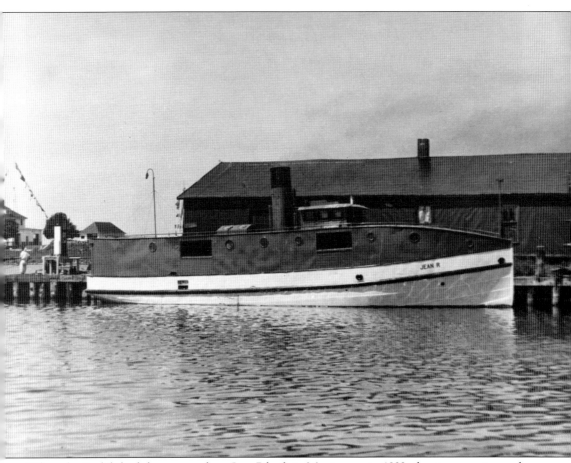

When the Rodals had the new steel tug *Jean R* built in Manitowoc in 1932, the steam engine and boiler were taken out of the *Francis C* and put into the *Jean R*. In February 1935, the vessel became stuck in the ice outside of Frankfort Harbor and sank about 50 feet off the breakwater. The crew managed to get to the breakwater, tie themselves together, and navigate the ice to safety. After this, crew member Pete Troan had had enough with winter fishing and moved to California to take up work on a tuna boat. In May, Luedtke Engineering raised the *Jean R* enough to tow it to Frankfort, where it was repaired and put back into use.

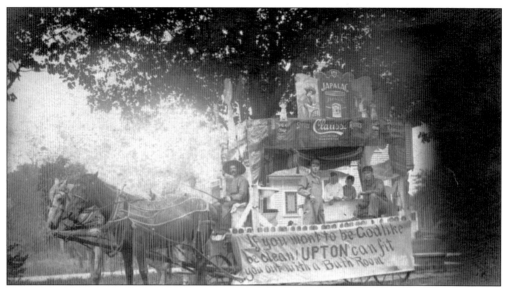

On a parade float, decked out with toilet, sink, and bathtub, Upton Hardware of Frankfort advertises a relatively new idea—and good source of income for a hardware store—indoor plumbing. The banner reads, "If you want to be Godlike, be clean! UPTON can fit you out with a Bath Room."

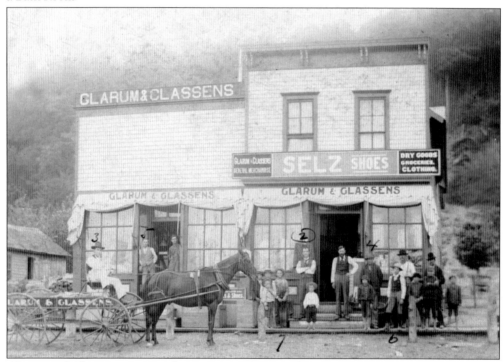

Glarum and Classens ran general stores in Frankfort, and, as shown in this picture, across Betsie Bay in Elberta. Identified from left to right are Harry Walker (driver's seat of wagon), Sievert Glarum (left in doorway), Conrad Vigland (child sitting on crate next to main door), Leonard Classens (standing under the Glarum portion of the sign), M.L.S. Glarum (right in doorway), Peter Matheson (standing next to Glarum), and Sievert Glarum (child in white hat).

In Thompsonville, the Wareham Grocery Store is shown with Kay and Ted Wareham pictured in the center. Before the age of self-service and shopping carts, few items were left out to be examined or picked over. A customer would instead provide a list to the clerk, who would then gather items and personally show the merchandise.

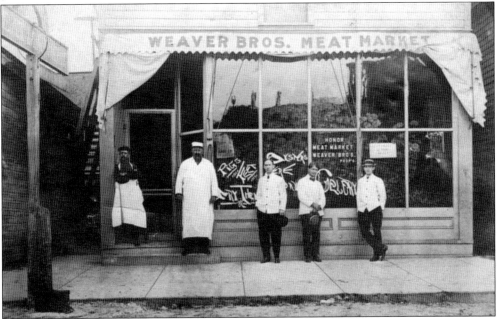

Orin Weaver, second from the left, was one of the proprietors of Honor's Weaver Bros. Meat Market. The writing on the window encourages customers to try pig's feet, which would go well with the sauerkraut advertised at 7¢ a quart. Local butchers also processed game, as indicated by the trophy head in the far right of the window.

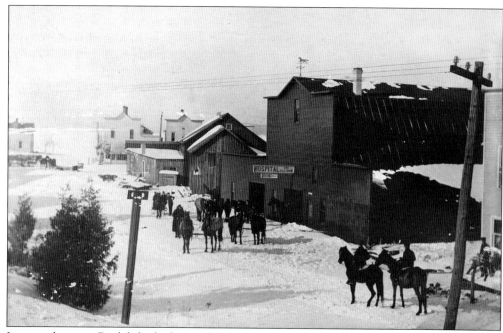

In its early years, Beulah had a hospital—a horse hospital—with veterinarian Fred Small. The horse hospital was also the designated spot for horse trading, with the hospital building used as the sale barn. Teams of horses stand hitched, and individual horses are led out of the barn to be inspected on sale day.

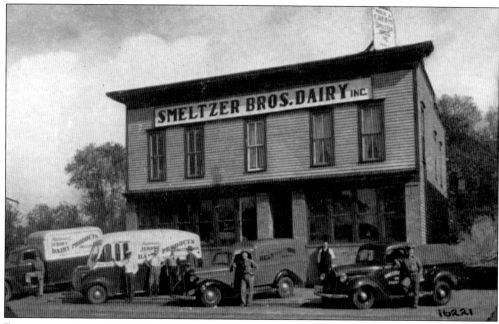

For many in Benzie and Manistee Counties, milk came from the Smeltzer Brothers Dairy. It was common practice until the middle of the 20th century, before second family cars and convenience stores were common, for milk to be delivered to a home on a regular schedule by a milkman.

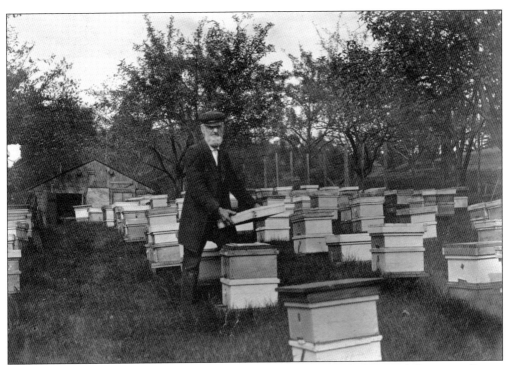

Critical to the fruit orchards of Benzie County are the apiaries, which provide bees to pollinate the blossoms. Common practice was for orchards to keep their own hives or to pay for the services of those who could tend them, such as Charles Hull Crittendon, pictured with his hives.

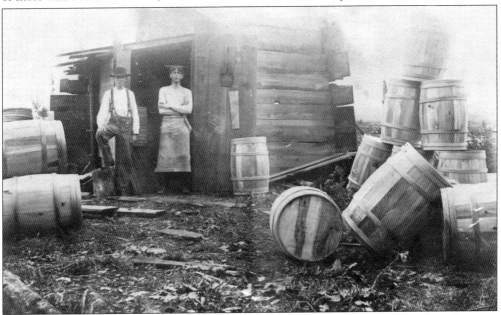

Glen Pierce (left) and Joe Bum stand in front of their cooper shop in operation at Elberta between 1910 and 1915. Coopers, or barrel makers, manufactured the shipping containers used by just about every industry. When packing apples, the fruit was crammed into the barrels and the lids hammered into place, crushing the top rows but securing the rest against bruising.

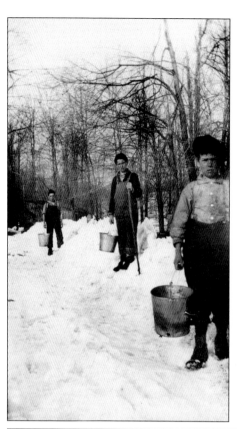

As they gather maple sap to be taken to the sugar bush in the background, three boys stop for a picture. In the days when all the gathering was done with buckets, children gathered at the sugar bush after school to collect the day's run of sap, which was then rendered to sweet maple syrup and sugary treats for the workers.

Harrison Long operated his sugar bush off Narrow Gauge Road in Benzonia Township. In this image, his season has come to an end with the last boil, the maple buds having burst, making the sap unusable for syrup. The wood is stacked and kept dry, and the steam escapes from the front.

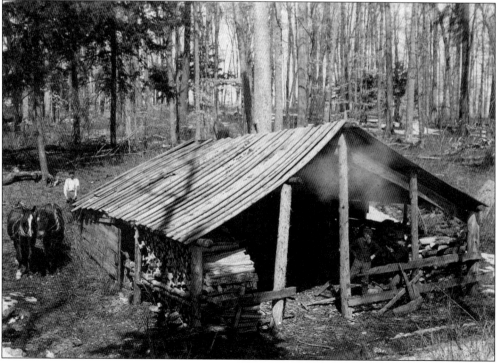

At the first cement block factory in Frankfort, Harry Collier is pictured (right) carrying a mold among the blocks, which had been set out to dry in the yard. The blocks, used largely for foundations, show a decorative quality in the "hewn" facing and are noticeable today in the older homes of Frankfort.

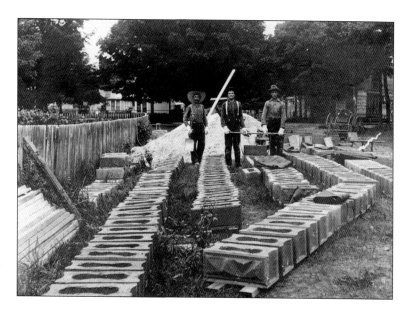

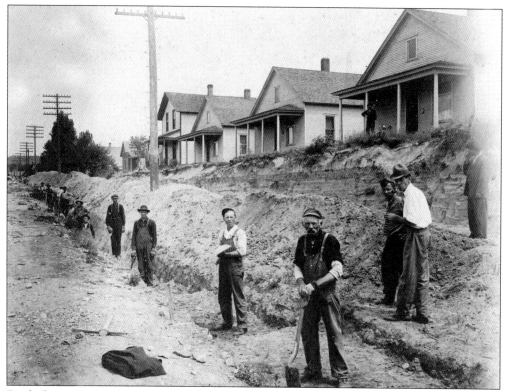

Ditch digger is not an occupation held by many people in this era, and those who do it today accomplish the lion's share of their task with machinery. In earlier days, it was a job done by hand, and one most any able-bodied person could do. Communities wishing to improve their infrastructure would hire crews, such as the one pictured in Elberta.

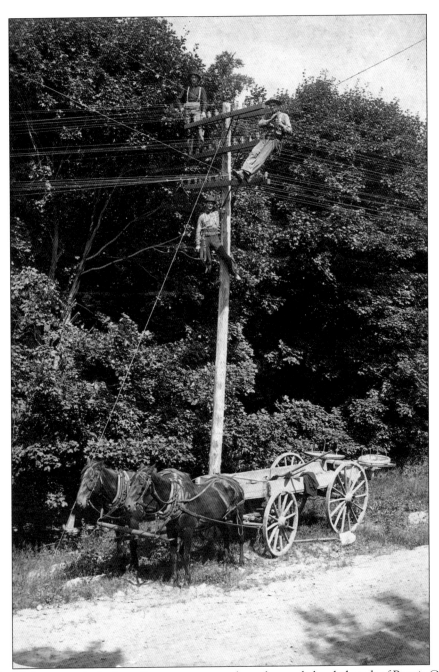

Overhead electric and telephone lines were strung along the newly leveled roads of Benzie County beginning in the early 20th century. The crews doing such work could use the skills they learned as lumberjacks. Overhead lines were not the first attempt at supplying electricity to the county. The initial owners and operators of the steam-powered electricity generators in Frankfort thought that laying cable across Betsie Bay to Elberta was an easier and less expensive route than installing overhead lines around the bay. This proved unworkable after an Ann Arbor car ferry became tangled in the line, shredding the cable and disabling the ship for several days. After damages were paid to the railroad, the electric company was sold, and overhead lines were strung.

On the corner of Fifth and Main Streets in Frankfort, Rose E. Fin was the first operator of the Benzie County Telephone Company, located in George Robinson's office. The exchange first opened on December 4, 1899. At this time, all calls had to be connected through the telephone operator who manned the exchange during limited hours.

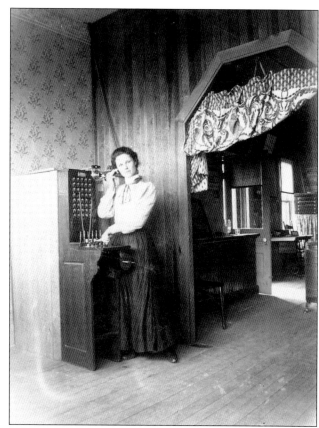

A later, more complex telephone exchange from Beulah is seen. Common at this time were party lines, where several households shared the same line and had to take turns using it. Different rings, long, short, and combinations of the two, indicated the household for whom the call was intended. This did not, however, mean that an unintended person was not able to listen to the conversation.

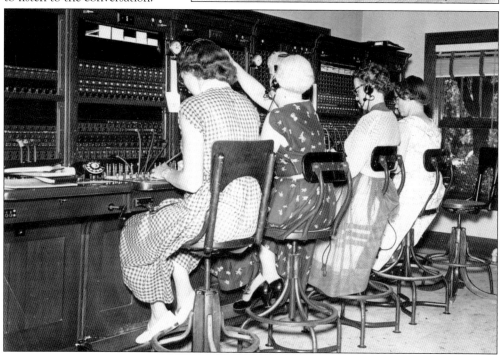

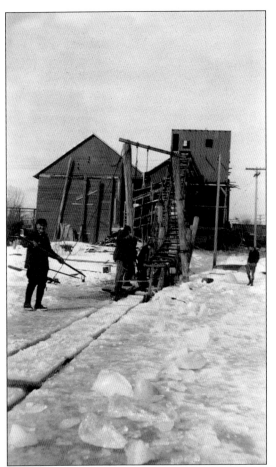

Carland's Ice House stood just off Betsie Bay in Frankfort. The ice, sometimes over two feet thick, was cut from the bay using a special one-handed saw and then cut into two-foot-square blocks for storage. Stacked floor to ceiling in the icehouse, the blocks were packed all around with a thick layer of maple and birch sawdust that kept it through the hot summer months.

Walter "Fattie" Scott and his dog take a load of ice through Honor in 1910, stopping in front of the A.B. Case store. From the icehouse, the ice was delivered to businesses and homes throughout the warm months and deposited in the icebox to keep perishables, like milk and butter, from spoiling.

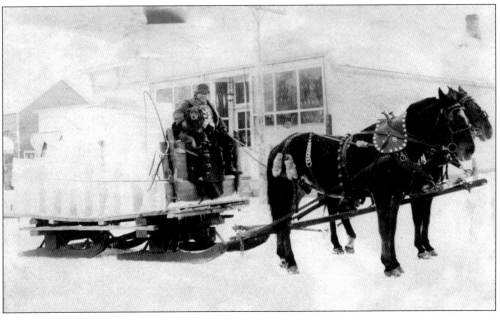

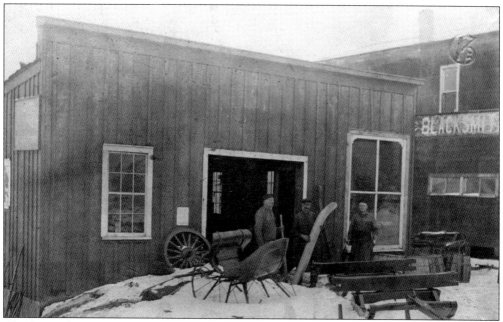

Charles Tucker and George Snell (center) appear at Snell's blacksmith shop in Thompsonville. Blacksmiths were important figures in communities, critical to providing the tools for just about any task, and their shops were always busy with activity. They fixed pots and pans, forged chain, crafted pieces for farm equipment, and made hammers, nails, axes, and horseshoes.

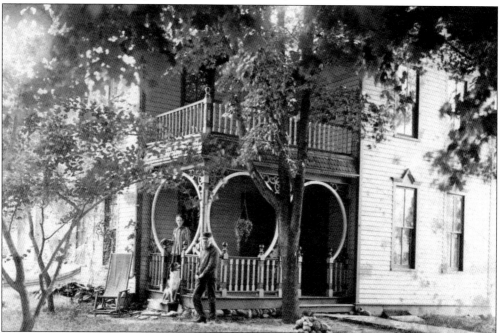

Still known today in Benzonia as the Spence House, this attractive house was built in 1878 by village blacksmith George Spence, who lived in it until his death in 1932. The front porch, with its unique circular decoration, was added in 1898. Like many skilled craftsmen of the time, Spence had his blacksmith shop on his home's property.

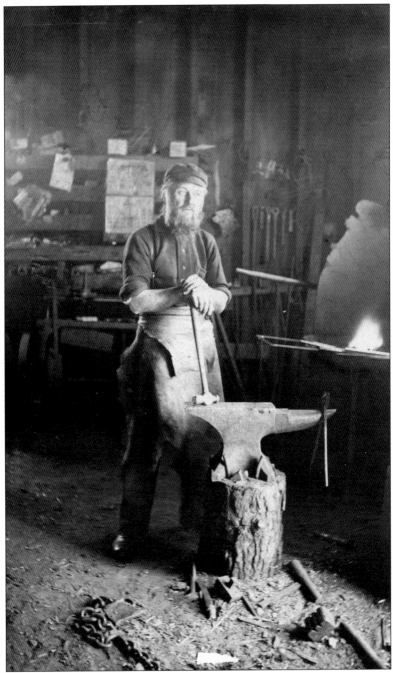

George Spence was the village blacksmith in Benzonia, and his life typifies many who came to settle in Benzie County. He was born in Kingston, Ontario, in 1853 to Scottish immigrants. He married Rebecca Cooper, of Elberta, in the spring of 1877, and they moved to Benzonia, where he opened a blacksmith shop. He and his wife had two daughters, the first born rather unexpectedly while visiting friends; mother and new daughter rode home several days later on a wagon fitted with a bedspring. George would serve as justice of the peace and also on the school and township boards. Rebecca died at age 76 in 1929, and George passed away in 1932.

# *Three*
# TRANSPORTATION

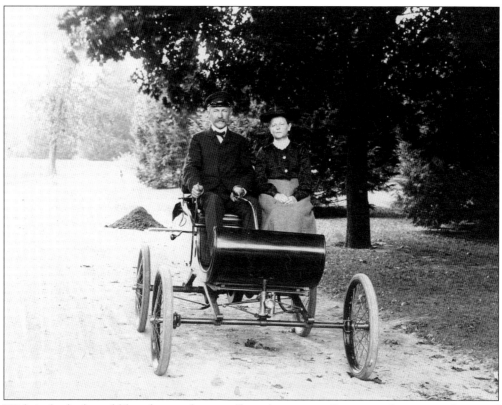

With its body shaped like a buggy, the term "horseless carriage" is an apt description for one of the first motor-powered vehicles in Benzonia; one is seen here driven by an unidentified couple. As the roads were impassable for much of the year because of the snow or poor conditions, such automobiles could only be driven in fair weather.

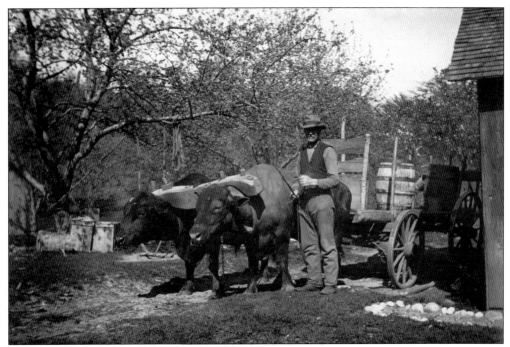

A team of oxen, harnessed to a cart, is seen here driven by Owen Sherwood on the John Twiddle farm south of Empire on the Benzie-Leelanau county line. The photograph, taken in 1907 by Ray Edwards, was made when Ray and his father, George, were on the Twiddle farm to erect a windmill.

In the lumber camps, oxen proved a reliable form of transportation for the heavy work of dragging logs through unbroken forests, as did this team owned by Anson Hawkins (right) in Lower Herring Lake swamp. The slapped-together wood and tarpaper structure behind them was the type of housing typically provided in mill towns.

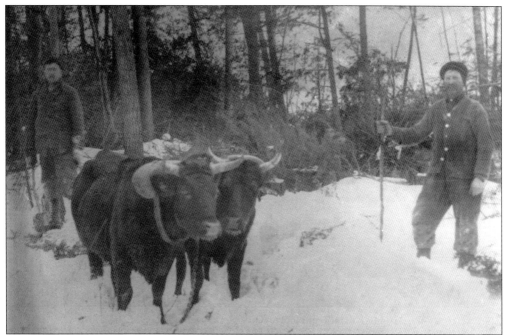

Anson Hawkins (right) poses with his much-photographed team of oxen. Slow moving, but sure-footed, oxen could navigate any terrain the loggers might encounter, from swampy bog to icy riverbed. The Hawkins family, which owned and operated a sawmill through the 1970s, was one of the longest-lasting mill operations in the county.

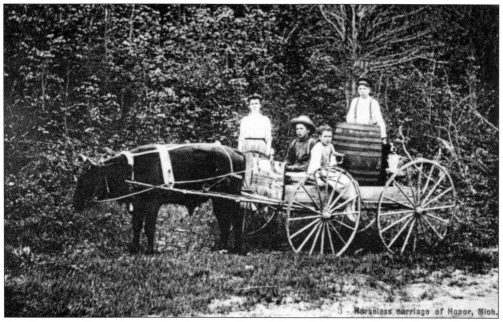

Another type of horseless carriage is pictured near Honor delivering a barrel of water for those working out in the fields. Oxen were not as fast as horses in farmwork, but they were less expensive to purchase, able to pull heavier loads more steadily, and less excitable.

Stopping off the main street in Honor, Dr. Ezra Covey and his family show off their attractive trap. Known as the best-dressed man in the county, Dr. Covey was a well-respected member of the community and an active participant in many social organizations in the county.

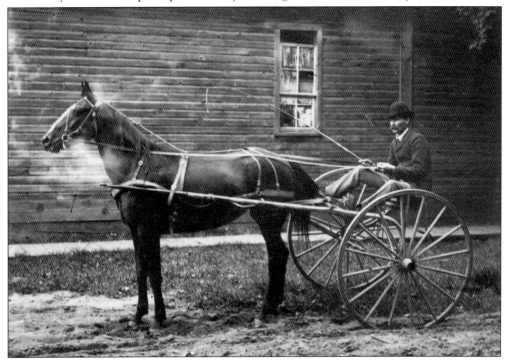

If a person did not need to transport anything but himself and wanted to make quick time, he could hitch up his sporty sulky to make a fast trip, as this gentleman in Elberta has done. With its large wheels and light frame, even difficult roads could be quickly traversed.

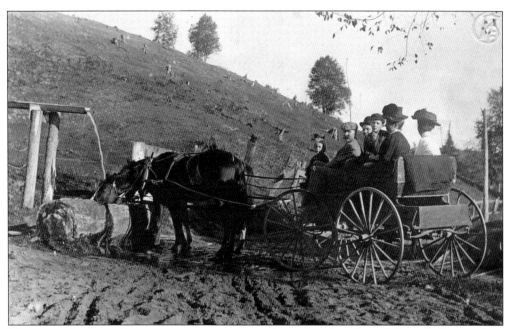

No matter the form of transportation, time must always be taken for refueling. Before gasoline stations were the norm, watering troughs fed by fresh springs dotted the farms and roads around the county. The Gibbs and the Tuckers, out for a ride in their wagon, make such a stop near a recently clear-cut hill.

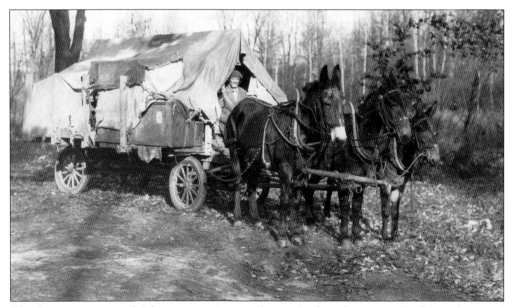

The first European and African American settlers arrived to the county by ship or boat and walked overland to their platted villages. When semblances of roads were traced, accounts of covered wagon trips were recorded. Not as picturesque or romantic as the type found in movies, Wilbur Bailey's covered wagon, pulled by a team of mules, gives a more accurate picture of this mode of transportation.

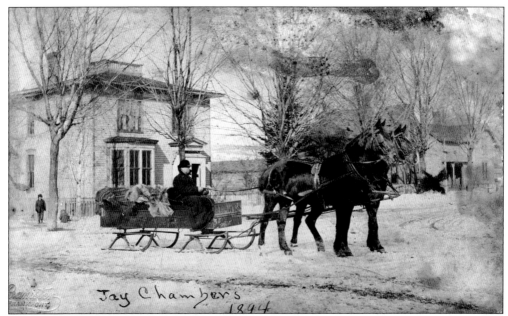

Unlike today, and despite the possible discomfort from the cold, transportation was actually easier and more reliable once the roads were covered with ice and snow in the winter. In 1894, Jay Chambers is pictured bundled up appropriately against the weather in his winter sleigh on the seasonally smooth street, possibly in Frankfort.

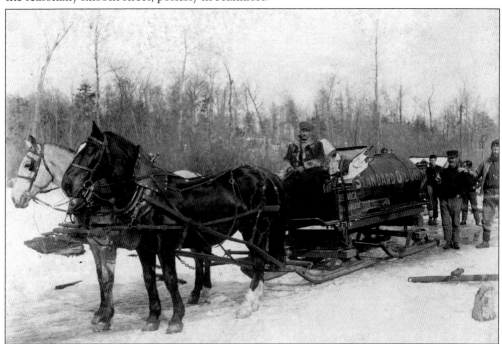

An icy street made an easier time of hauling heavier loads and a quicker and smoother ride for passengers. In a 1903 photograph, a man identified only as Slim makes a delivery of a Standard Oil product, possibly kerosene. Before automobiles made good use of it, the waste product of kerosene production, often dumped into the rivers near the processing plants, was gasoline.

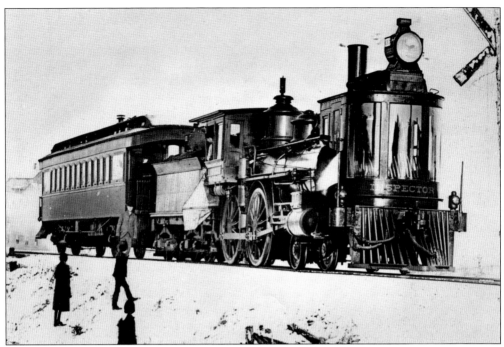

The major rails contributing to the growth of Benzie County were the Pere Marquette and the Ann Arbor. Above, a photograph shows an inspector train from the Chicago & West Michigan Railway (C&WM), which ran from Chicago to Petoskey. After going bankrupt, the company was purchased by the Pere Marquette Railway in 1894, and the inspector engine, with its unusual bay window for examining the track and grade, became the Pere Marquette engine No. 1. Below, an Ann Arbor engine rests on Betsie Bay in Elberta. The Toledo, Ann Arbor & North Michigan Railway was formed to transport goods to Elberta (Frankfort), where specially made railroad ferries delivered the railroad cars to ports around Lake Michigan.

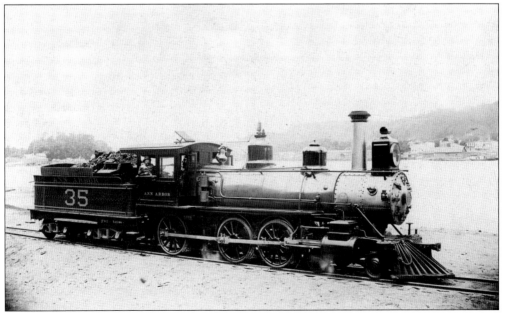

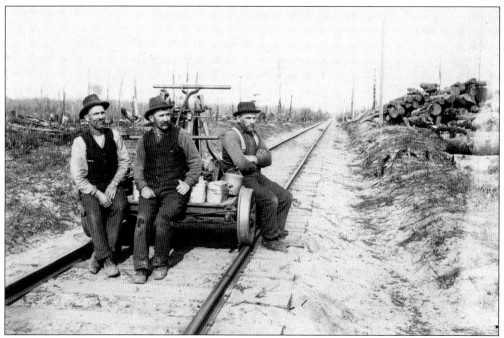

Train wrecks were all too common of an occurrence, and the critical job of inspecting and maintaining the track fell to the line crews. Above, railroad workers, with their lunch pails packed and their water jugs filled, would set out each morning for the day on the line. From left to right are William Marcham, Mike Obrien, and Thomas Stewart. On their handcars, propelled under their own power, they carried the picks and shovels used to keep the tracks clear and the trains running safely. Through all four seasons, the line workers tended to their task. Below is the crew from Honor going to work the line in winter.

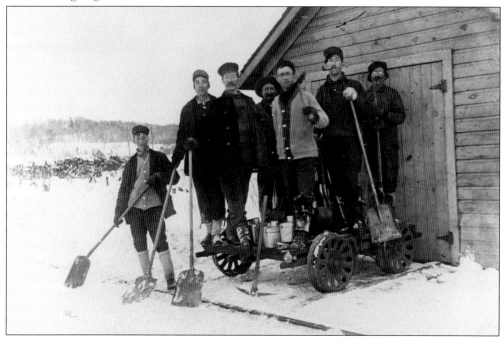

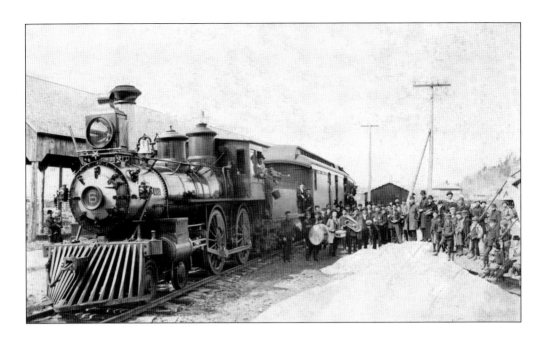

Another important railroad in the history of Benzie County is the Frankfort & Southeastern. Above, a delegation from Lake Ann prepares to return home from Frankfort after a party was given by the residents of Frankfort in honor of the residents of Lake Ann, thanking them for their votes in making Frankfort the Benzie County seat in 1895. The Frankfort & Southeastern was built to connect goods and passengers to the major lines in Thompsonville. Below, teamsters stand ready to unload goods from the railroad boxcars in Elberta, at one time known as South Frankfort, which was the main freight depot for the railroad.

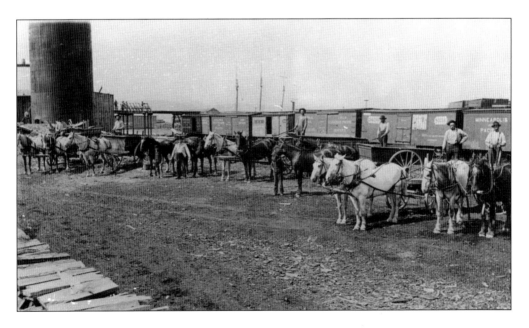

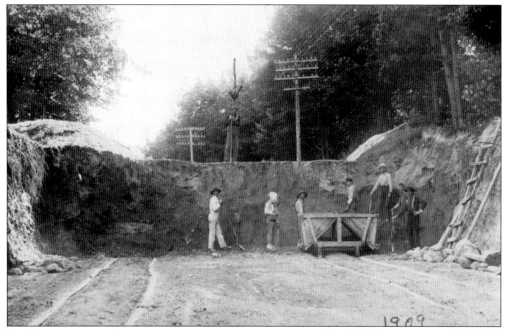

Road improvement always means economic improvement, and in 1909 the cut was made on the Beulah Hill for a better road. The engineer, Fred Bailey, is seen standing on top. As ground was excavated, it was loaded in dumpcarts and conveyed down the hill on a wooden track. Carts were returned up the hill by a team of mules.

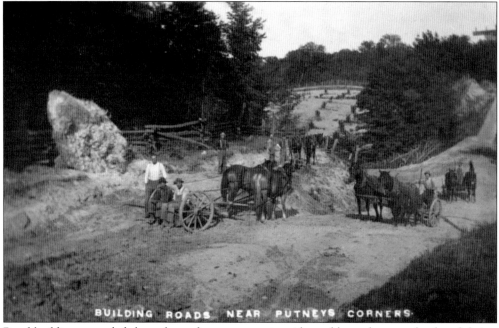

Road building extended throughout the county, as is evidenced by a photograph of work being done around Putney Corners, where teams of horses are being used to pull graders. Names for smaller communities and sidings were never regularized, such as Putney Corners or Carter Siding, sometimes written as "Putney's Corners" and "Carter's Siding."

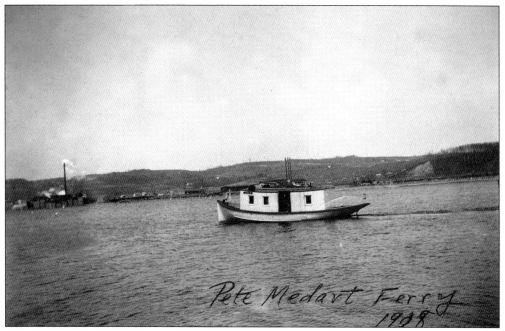

With so much water and so few roads, many times the quickest and easiest mode of transportation was by a boat that could serve many purposes. Most any boat in Betsie Bay could double as a ferry, but there were some dedicated solely to that purpose. Pete Mordart (or Merdart) operated a ferry that shuttled people between Elberta and Frankfort.

The Bell Ferry is seen navigating among the harbor's larger ships. The major railroad terminus was on the Elberta side of the bay. The quickest and most convenient way for crew and passengers to get to Frankfort was with a ferry, which cost 5¢. To call a ferry, a large bell was hung on either side of the bay, and so the service became known as the Bell Ferry.

Short-range travel on Lake Michigan with a smaller vessel operated by steam was always a challenge, but a few boats did venture out onto the Big Lake to provide passenger service between the port towns that dotted Michigan's west shore. One such boat (shown above and below), the *John D. Dewer*, owned by Henry Robertson, ran a route between Manistee and Frankfort in the early 1900s, with stops in Arcadia and Onekama. When train service and bigger passenger ships became more readily available, the *John D. Dewer* remained largely on Betsie Bay and was even chartered by the Ann Arbor Railroad to act as an icebreaker for its first ferries.

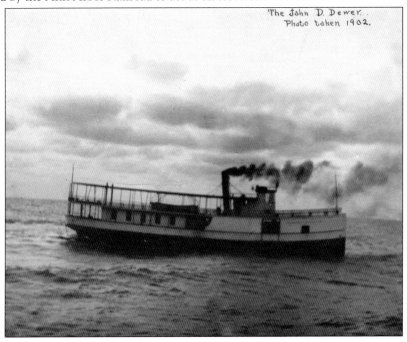

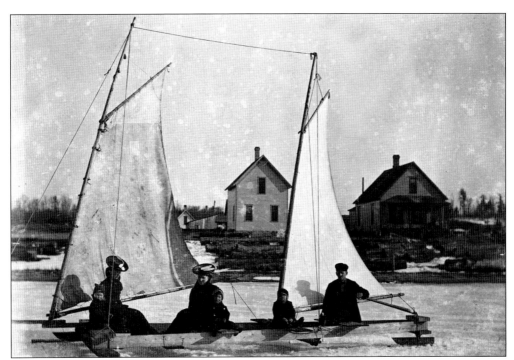

For speed, if not comfort, few things could match ice sailing. Children would ice sail on the lakes and rivers using just sheets and shoe skates. Pictured is a more advanced iceboat; it had plank seating and foot rests, for those with skirts, to keep their feet up. On the iceboat are, in no particular order, Aunt Winnie and Thelma Mae Tucker; the adult man is Harold Edmund.

The *Cynthia*, built by George Waters in 1876, was used to ferry people around Betsie Bay and into Lake Michigan. Captain Waters, a colorful local character who lived to be 97, housed himself for several years in a commercial fisherman's net house. He reportedly told friends to have the Coast Guard tow his boat if they found it unattended, as he would have gone "over the side with a stone."

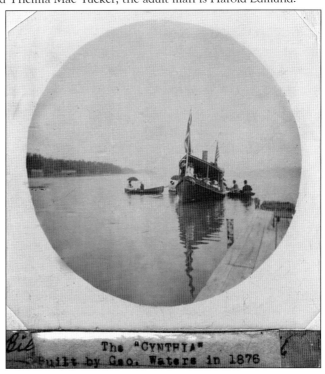

83

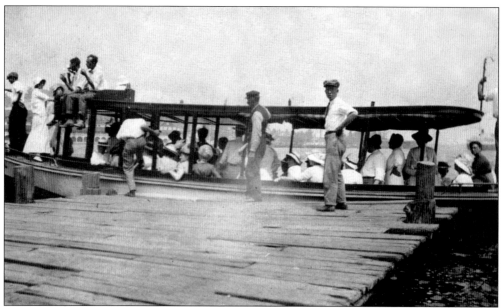

Although difficult to make out, the Royal Hotel Frontenac sits on the horizon to the left, under the pleasure seekers sitting on the roof, as they prepare to go out on the launch in Elberta. Once on Betsie Bay, day trips and excursions to multiple sights, restaurants, and resorts were a short boat hop away.

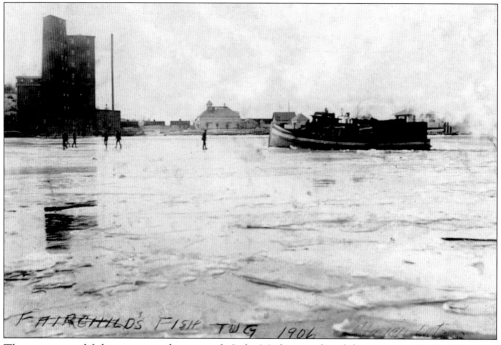

The commercial fishing tugs, seeking mostly Lake Michigan whitefish, went onto Lake Michigan as long as the ice was not too deep or too packed. In this picture, the first steam-powered fish tug on Lake Michigan, the *Maggie Lutz*, built in 1873 and owned by Albert Fairchild, returns to the harbor through the ice. The ice is solid enough for people to skate on Betsie Bay.

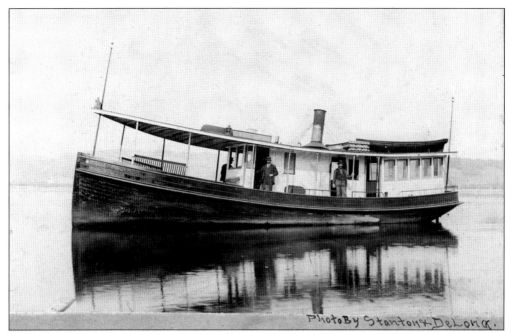

The men and boats that worked the waters of Betsie Bay and Lake Michigan were multitaskers. Capt. Charles Frederickson, who was an Ann Arbor ferry captain, took a leave and tried his had at commercial fishing. Commercial fishing companies often operated launches, such as the elegant *Pottawatomie*, which also functioned as a tugboat.

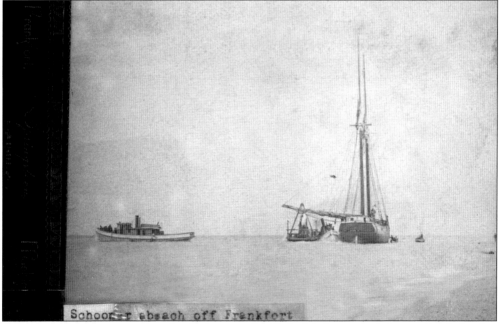

A schooner has run aground in the shifting sands of Lake Michigan, and the tug-freight-hauler-fishing boat *T.D. Holton*, owned by A.J. Slyfield and his sons, is assisting. The Slyfields were also known as Point Betsie Lighthouse keepers. Seen between the dredger and the schooner is the tugboat *Bamble*, on which Captain Waters served.

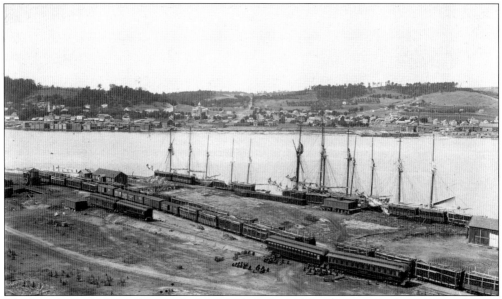

The busy hub of Elberta (or South Frankfort) and Frankfort are seen with a variety of boats and ships along their docks. Above, before the Ann Arbor car ferries arrived in 1890, Elberta is pictured with ships and lumber hookers docked; Frankfort is visible across Betsie Bay. In the foreground, maintenance on the jacked-up passenger car is being performed, with an assortment of different sized railroad wheels in the train yard. Every flatbed car on the train tracks is stacked with lumber to be loaded. People in the towns could identify each docked schooner by the masts and rigging and each steamship by its smokestacks. Below, the railroad yard is pictured with the tracks leading to the ferries (out of the picture).

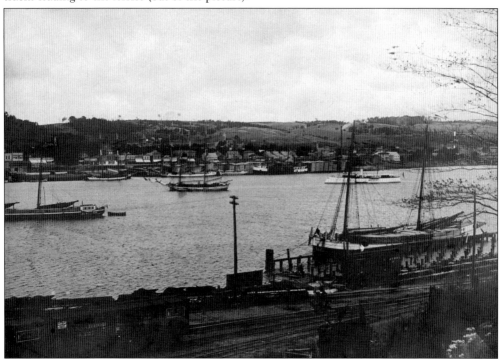

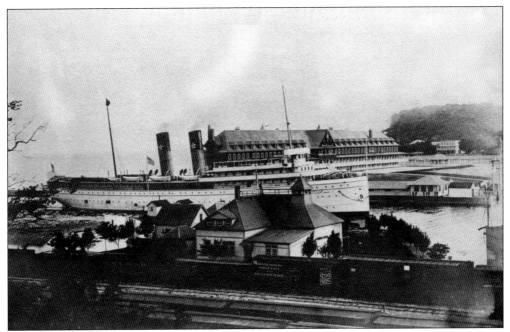

The *North Land*, a passenger steamship built to give cruises on the Great Lakes and specifically a seven-day cruise from Buffalo to Duluth, comes into Betsie Bay. The Hotel Frontenac is seen behind the ship, and the Elberta Life Saving Station rests between it and the railroad cars. The Park Hotel is also in view at the far right.

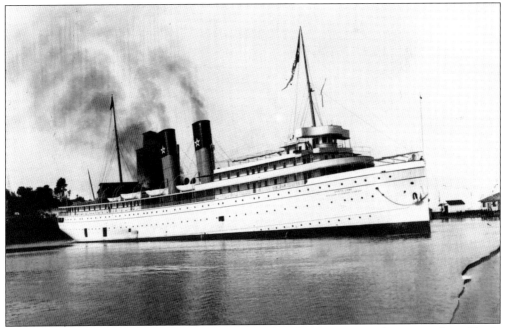

The *North Land*, operated by the Northern Steamship Company, was a frequent sight in Betsie Bay and considered one of the finest luxury liners on the waters. Mark Twain even traveled on the *North Land*, cruising from Cleveland to Mackinac Island, "the Bermuda of the north," in 1895. The motto of the steamship company was, "In all the world no trip like this."

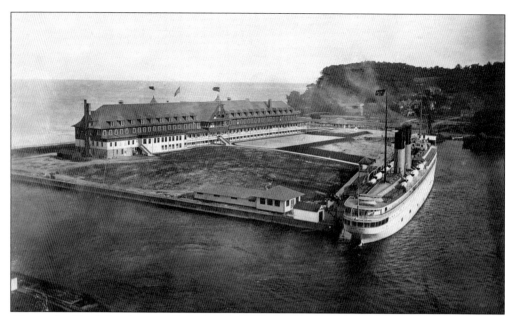

Above, the *North Land*, out of Duluth, has docked at the pier behind the newly opened Royal Hotel Frontenac in 1902 as passengers disembark. Travel to Benzie County in the 1890s and early 1900s meant traveling by steamship or railroad. In the summer months, thousands of tourists from as far away as St. Louis—but mostly from Chicago, Toledo, Cleveland, and Detroit—traveled by steamship to the ports along the shores of Lake Michigan. Below, sitting to the north of the Frontenac is the Ann Arbor Railroad depot, where the passengers could take the train inland to other resorts around Crystal Lake or even farther afield to Platte Lake.

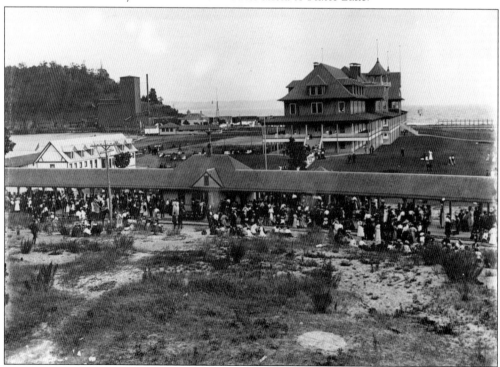

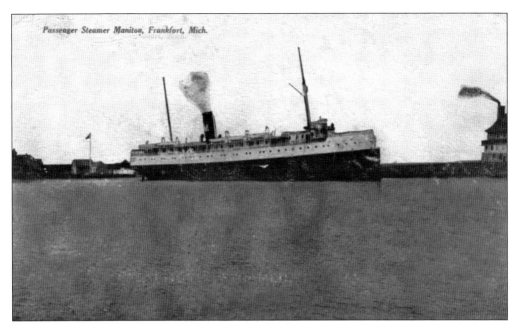

The 200-foot-long, wooden *Manitou* was originally designed as a fishing vessel in 1903 for the Dominion Fish Company out of Winnipeg, Canada. It was soon refitted as a passenger ship, and it is seen here passing the Hotel Frontenac in Frankfort before 1912. It was run by the Muskegon Transit Company and operated out of Chicago for service to Lake Michigan ports. It was retired from service in 1946.

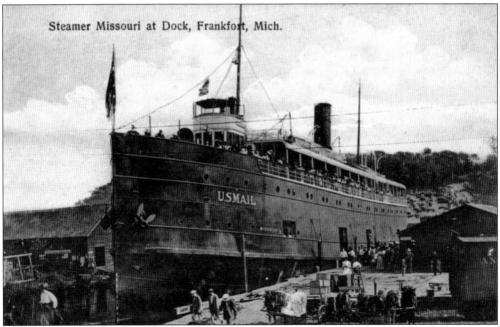

In addition to carrying passengers, steamships, such as the *Missouri*, also carried the US mail, goods, and fresh produce. Because of the frequency of the stops and the easy travel distances, both fresh fish caught out of the waters near Frankfort in the early morning and fresh produce picked and packaged in Benzie County could be on a Chicago supper table the same day.

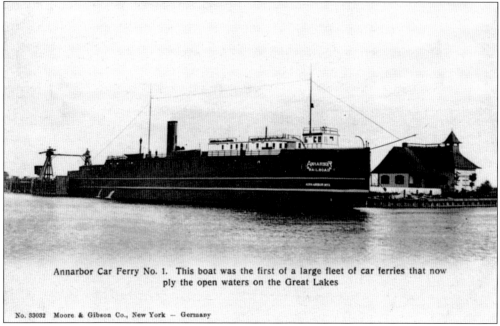

Annarbor Car Ferry No. 1. This boat was the first of a large fleet of car ferries that now ply the open waters on the Great Lakes

No. 33032 Moore & Gibson Co., New York — Germany

The ships best known and most affectionately remembered in Frankfort Harbor were the ferries of the Ann Arbor Railroad. The railroad's Toledo investors intended, for the first time, to cross a major body of water with a railroad ferry to avoid the shipping bottleneck of Chicago. Seeking investors in Ann Arbor, Michigan, the railroad came to be known as the Ann Arbor Railroad and chose Frankfort as the Michigan terminal for the ferry crossing. In 1892, the specially designed and constructed ferries began service. Above is Ann Arbor No. 1, and below is No. 2, made from wood and with propellers in the bow for ice breaking. They remained in service until 1912.

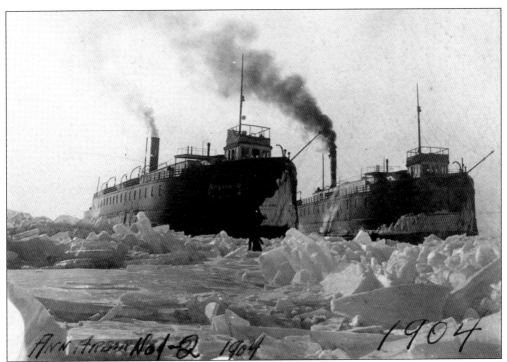

The Ann Arbor Railroad intended to cross Lake Michigan on a regular schedule, and so it had to deal with two major problems: winter ice and shifting weight. In the first years, until the techniques of ice breaking and stronger-hulled ships were successfully employed, the ships spent many days caught in the ice. Shown above in 1904, No. 1 and No. 2 aid one another in ice breaking. The second problem—shifting cargo that could cause the ferries to lilt, take on water, and even capsize—could be a problem at any time of the year. To remedy this, a special system of redundant fasteners, pictured below, deployed as needed depending on the weather and used to keep the railroad cars fast.

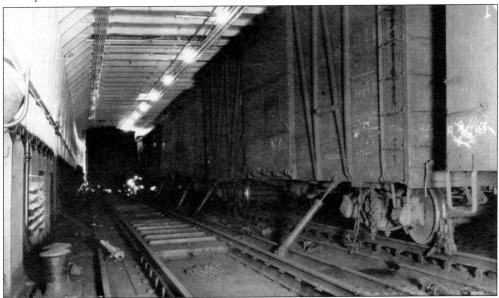

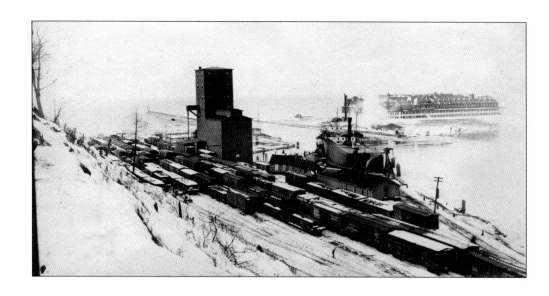

Two docking slips were designed and placed at the railroad yard in Elberta to allow the ferries' sterns to connect directly to the railroad tracks. Once in place, an engine simply unloaded the freight cars from the other Lake Michigan ports and then loaded the outbound cars onto the ferry. The other harbors served by the Ann Arbor Railroad were Manitowoc, Kewaunee, and Menominee, in Wisconsin, and Manistique, in Michigan. Above, with the Royal Frontenac Hotel in view, a ferry prepares to take on a load of cars. Below, a water-level view of the west slip is seen as the Ann Arbor No. 3 sits in the east slip.

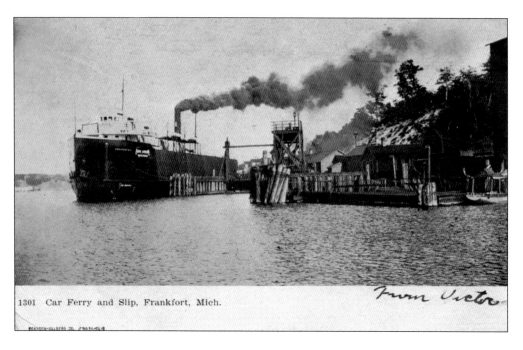

1301  Car Ferry and Slip, Frankfort, Mich.

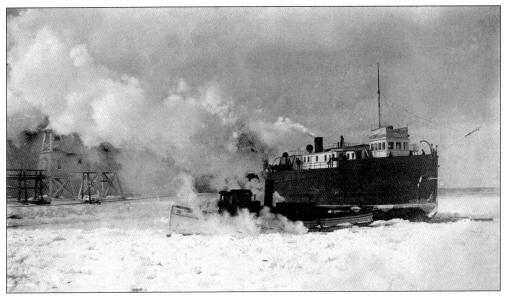

The Ann Arbor No. 2 is given a tug through the ice jam by the tugboat *Anna L. Smith* in the winter of 1907. The Ann Arbor Railroad would charter local fishing, passenger, and freight tugs to help with the ice breaking in the harbor and to assist in towing and docking ferries when the conditions required assistance.

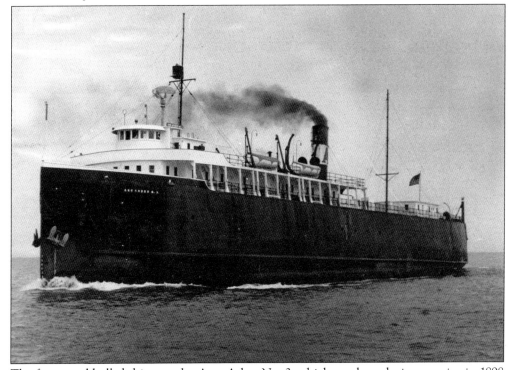

The first metal-hulled ship was the Ann Arbor No. 3, which was brought into service in 1898 and extended the so-called "tracks on the water" until 1959. Like No. 1 and No. 2, it was built with a double bottom so that it could also haul grain. In 1922, it was lengthened by 48 feet and refitted with new engines and boilers.

93

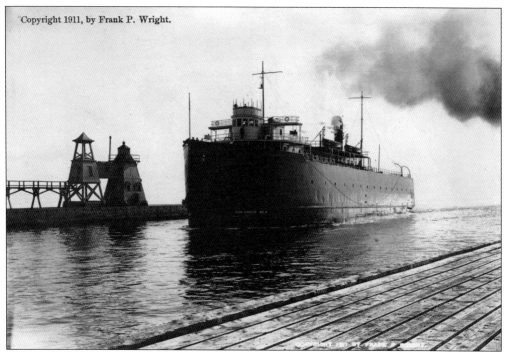

Copyright 1911, by Frank P. Wright.

No ferry was ever lost, but the Ann Arbor No. 4, most storied of the ferries, came close to being lost several times. In May of 1909, because of an unbalanced cargo of iron ore, it rolled in its slip in Manistique. A more dangerous incident occurred in February of 1923. In a bad storm, cars came loose and shifted the weight, with one car going overboard. Listing badly as it came into Frankfort Harbor, it hit the south pier where it then hit bottom. When the storm ended later that day, the crew walked over the ice to safety. The photograph above shows No. 4 entering the harbor, and below it rests at the south pier after it ran aground. In the spring, it was raised, towed to a shipyard in Wisconsin for repairs, and returned to service.

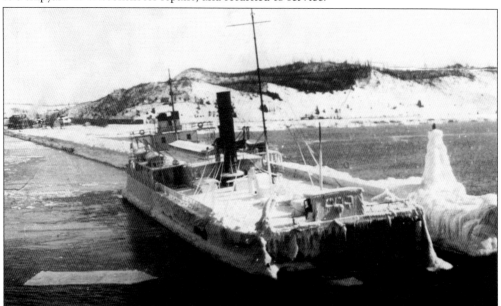

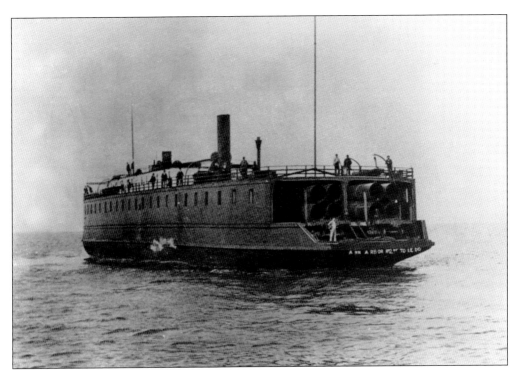

As seen above on the Ann Arbor No. 2, which is carrying a load of pipe on the railroad flatcars, an innovative design was for loads to be taken through the stern rather than the bow, which allowed it to remain open for easier loading and unloading. However, with high seas, it was not always possible to keep water from flooding the car deck, and there was always a danger that enough flooding could sink the ship. As seen below on the retrofitted stern of Ann Arbor No. 4, the ferries were later designed and fitted with sea gates that lifted to help keep out water—and if need be, help keep in a loose car.

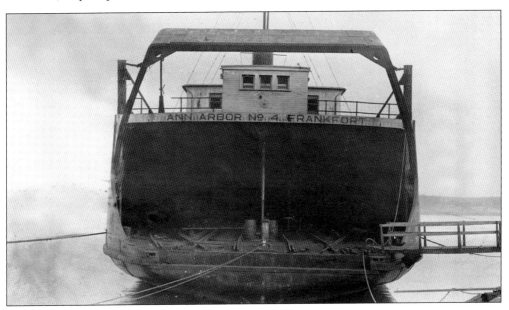

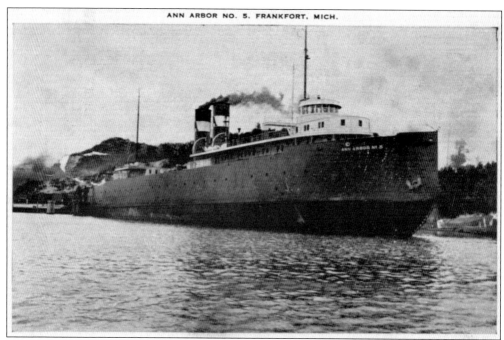

The 360-foot-long Ann Arbor No. 5, built in 1910, was the largest Great Lakes ferry of the time. The "5-spot," as it was known, was the only Ann Arbor ferry with straight, un-raked stacks. During its nearly 50 years of service, the "Bull of the Woods" or "Old War Horse" was noted for its ice-breaking abilities. It was also the first ship with a sea gate.

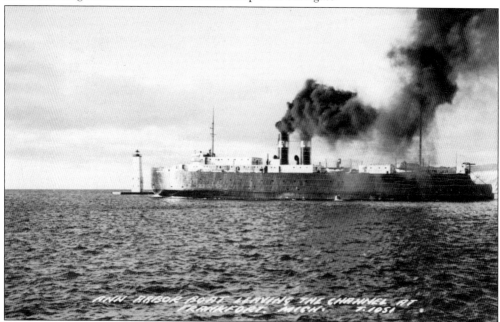

The Ann Arbor No. 6 was built in Ecorse, Michigan, at the Great Lakes Engineering Works. It was the only ship not specially designed for the Ann Arbor Railroad. Its maiden voyage from Detroit to Frankfort in January and February 1917 took 21 days. This was one of the few times Lake Michigan froze all the way across.

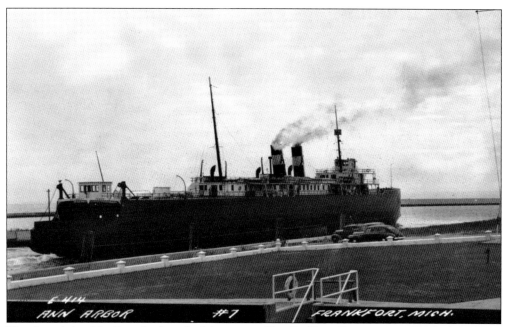

The Ann Arbor No. 7 was built at the Manitowoc Ship Building Company in 1924 for $1 million. It was considered to have fine lines and was fast, making the 75-mile crossing between Manitowoc and Elberta in five and a half hours. In 1929, it made 993 trips.

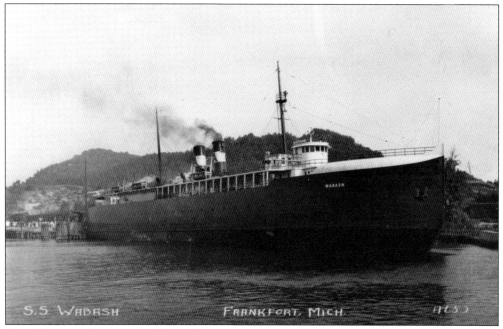

The *Wabash* was built at the Toledo Shipyards in 1927. It was owned by the Wabash Railroad and leased to the Ann Arbor. The flagship of the fleet, she had a turtle deck, which is an enclosed bow area. In 1962, the Wabash was converted from coal to oil and renamed the *City of Green Bay*.

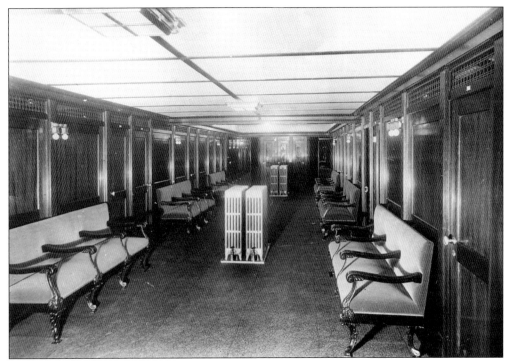

The passengers' waiting room from the *Wabash* is pictured. Although the ferries were originally not designed or designated for passenger and automobile service, exceptions were made, and especially in the later years they carried both as a regular service. The crews' quarters also became more comfortable over time.

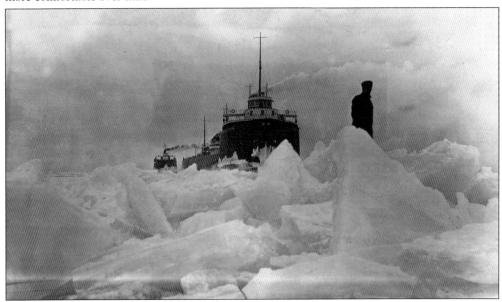

Outside Frankfort Harbor, a lone figure stands on the ice with the Ann Arbor No. 5 and another unidentified ferry behind. Unlike saltwater ice, the freshwater ice of the Great Lakes is dense and more difficult to break and navigate. For 90 years, between 1892 and 1982, the ferries and their crews dealt with the hazards of sailing through the ice.

# Four

# Resorts

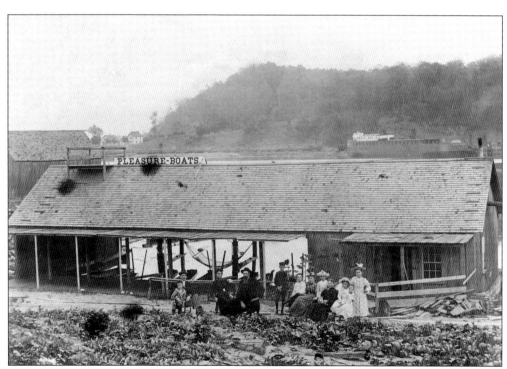

At the Norman Boat House in Frankfort, across from the Ann Arbor Railroad yards in Elberta, pleasure boats could be rented. With the first railroads and passenger steamship service on the Great Lakes in the late 1880s, the resorts, cottages, campgrounds, and industries that supported them flourished. Many continue to the present day, but many others have faded from the scene.

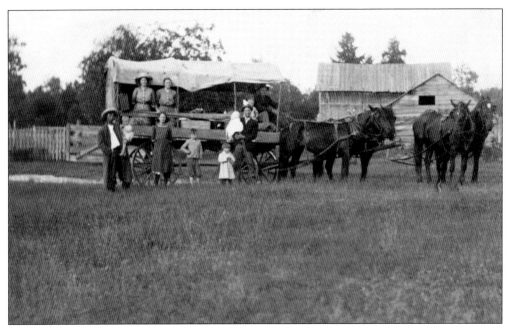

Above, on July 6, 1913, the Mow and Groshorn families return from their Fourth of July camping trip at Herring Lake. Below, a camp on Herring Lake along Swamp Road is pictured. From a current perspective, heading off into the woods with horse-drawn wagons to cook over wood fires, when the usual mode of transportation was horse-drawn wagons and cooking done on wood-burning stoves, may seem redundant. However, it was the pioneer spirit—a celebration of those who came in the covered wagons—that moved families to honor their heritage with camping trips in the nearby woods and forests. Visitors from the major cities journeying to Benzie County would also plan camping trips from the resorts and hotels as part of their vacation activities.

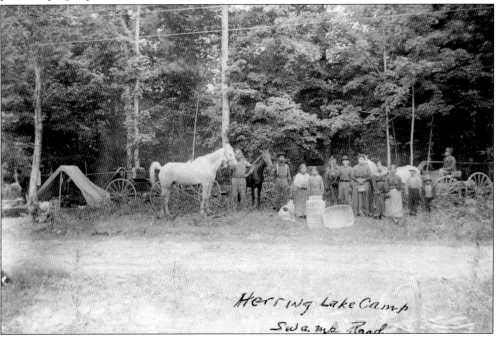

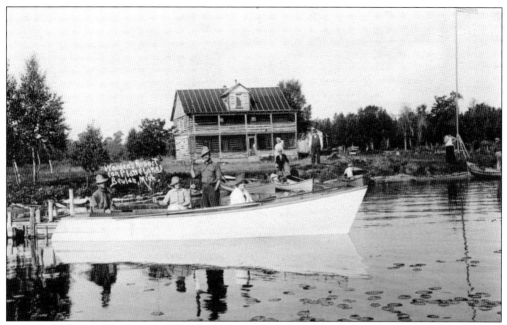

Built by William Worden, the Worden Resort was one of the better-known resorts on Platte Lake. He was called the "man who owned all the fish in Platte Lake" and was renown for his storytelling. It was said that no visit to Benzie County was complete without a day spent fishing with Bill Worden on Platte Lake.

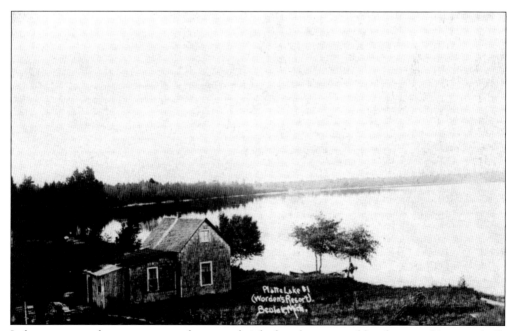

In later years, as the resort grew and car travel picked up, lots were sold and more cabins were built at Worden's Resort. In addition to the fishing, one of the draws to Worden's became its Cypress Gardens–like water-skiing performances put on by the young men and women who lived around the lake and worked at the resort.

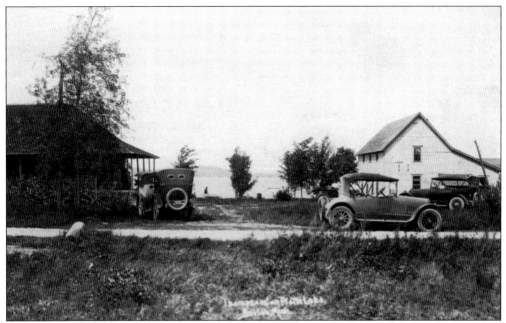

Because of the lack of good roads, a railroad, or an easily navigable outlet to Lake Michigan, the area around Platte Lake was a little off the beaten path but considered well worth the reward. Enterprising farmers and settlers invited tourist groups into their homes and built cottages to accommodate the demand. Once good roads were built, resorts like Thompson's flourished.

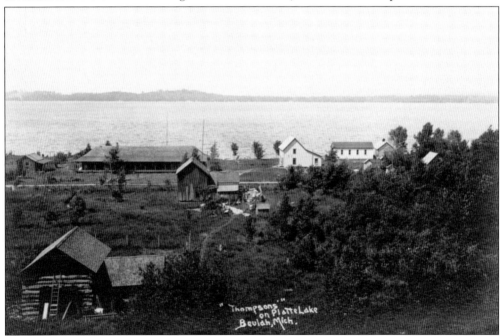

Nearest to Honor and the railroad, Thompson's Resort and Hotel was owned and operated by Billy Thompson and his family; it consisted of 20 cottages and regular hotel facilities for the many fisherman who came to the lake. Always filled during the season, the hotel also attracted visitors from neighboring resorts and towns with its famous fish dinners.

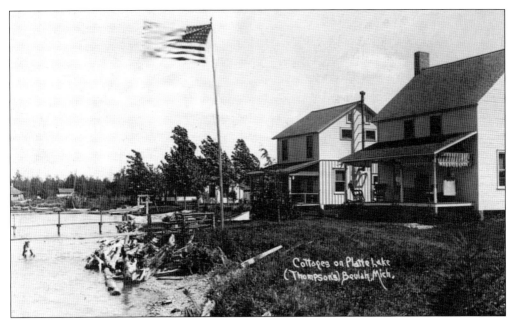

A postcard from 1917 shows several attractive cottages on Platte Lake kept by Thompson's Resort. The many bays and inlets around Platte Lake were scenic respites in which people from Detroit, Toledo, Cincinnati, Cleveland, and Chicago built cabins and cottages seeking out the cool lake breezes and exceptional fishing.

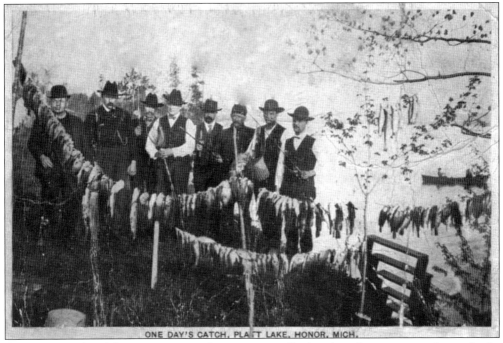

Platte Lake and its fishing was written about in nationally distributed magazines and periodicals, and the effort it took to get to its shore in the earlier days added to its mystique. Muskie, bass, northern pike, and perch were all caught in abundance. Sturgeon weighing 35 to 40 pounds were even landed on occasion.

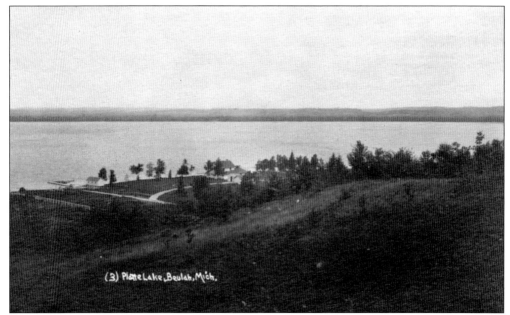

As the fishing in Platte Lake gained national attention, more people came from farther afield to build summer homes. Coming from Oklahoma, W.R. Wilcox built of one of the finest summer cottages (pictured) in the county on Platte Lake, with 500 feet of tile drained frontage, a roomy home, and well-kept lawns and flower gardens.

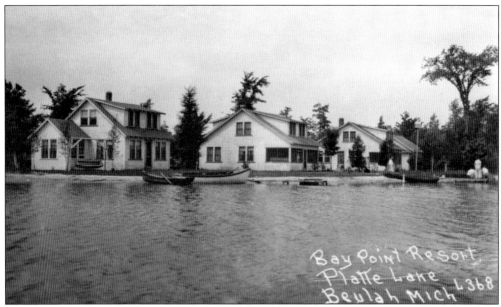

A popular activity for summer residents was drifting down the Platte River to Lake Michigan and rowing across the river expansions that turn into lakes. In early afternoon, a lunch and coffee, cooked with driftwood on the Lake Michigan shore, capped the trip. After time was given for swimming, launches from the resorts arrived to tow the party back to their Platte Lake resorts, such as Bay Point.

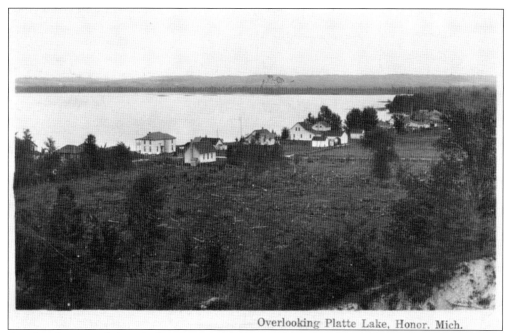
Overlooking Platte Lake, Honor, Mich.

As often happened, friends from organizations and towns would vacation together, beginning the tradition of traveling en masse to Benzie County. Over time, they purchased adjoining lots or common property and set up resort neighborhoods. One such group came from Muskingum College in Ohio, where they built the Muskingum Club, the larger building that appears left of center.

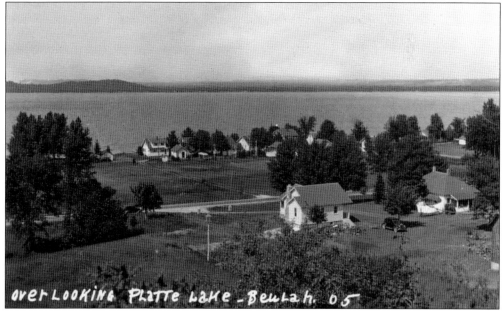
overLooking Platte Lake - Beulah. 05

White City, a resort community on Platte Lake, consisted of families from Pemberville, Ohio. Hearing about the fishing, they came and set up their white tents on Joe Vinson's farm property along the lake. Vinson sold lots to the group, who then built cottages. In honor of their first visits, they agreed to always paint their cottages white like the original tents.

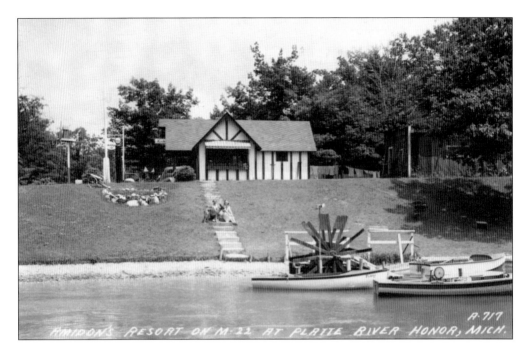

Until becoming part of Sleeping Bear Dunes National Lakeshore, Benzie State Park occupied the land between the northwest shore of Platte Lake and Lake Michigan. Near the Platte Lake outlet and where the highway crossed the Platte River, a paddlewheel seen from the bridge became a well-known landmark. The paddlewheel was built by Happy Amidon at his resort and campground at the entrance to the state park. Bob and Edith Miller would add to the attraction of the river by operating the *Paddle Princess* into the 1970s.

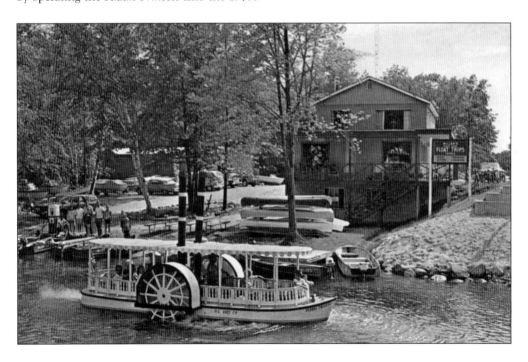

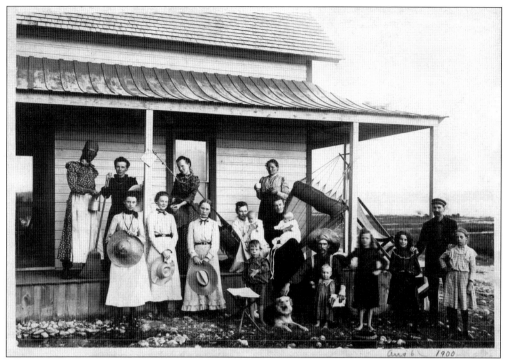

For the families fortunate enough to have their own cottages, summertime was a season of cool breezes and long days. The names given to the cottages reflected the laid-back atmosphere, such as the Clark Cottage on Crystal Lake, which was designated "Fool's Rest." Taken in 1900, this photograph indicates amusement of a different time and place, as the man dressed as a woman on the far left is in blackface.

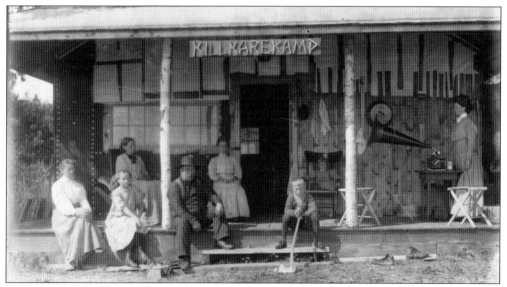

On Lower Herring Lake, a photograph of the Kilkarekamp cottage shows, from left to right, Louise Carver, Caroline ? , Mrs. Westerland, George Edwards, Anna R. Edwards, Dean Edwards, Ruth Edwards, and Nellie Westerland (manning the phonograph player). Taking the picture is Ray Edwards, whose photographs on glass plates so clearly recorded life in and around Benzie County.

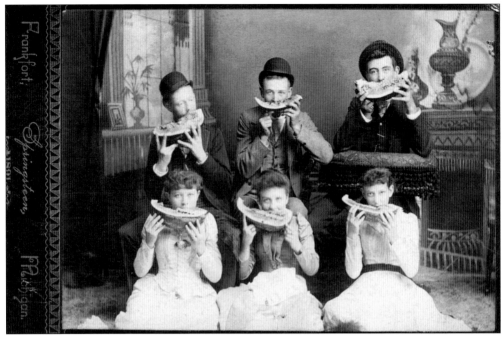

Important Crystal Lake names are recorded on this photograph; however, due to their youth and the watermelon covering their faces, Harry Collier and Reinhold Pautz cannot be clearly pointed out. Collier would go on to be a businessman in Frankfort, and Pautz would go on to own Pautz's Resort on Crystal Lake.

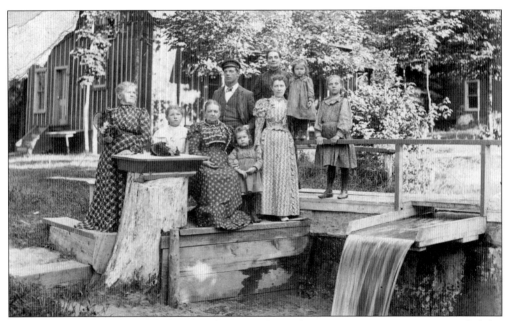

To the people at the end of the 19th and start of the 20th centuries, Pautz's Resort provided the perfect backdrop for a photograph. Open to the public, the resort on Crystal Lake was a popular picnic site. Families, school groups, and business associates all came to this bridge and spring for outings—and to have the occasion recorded with a photograph.

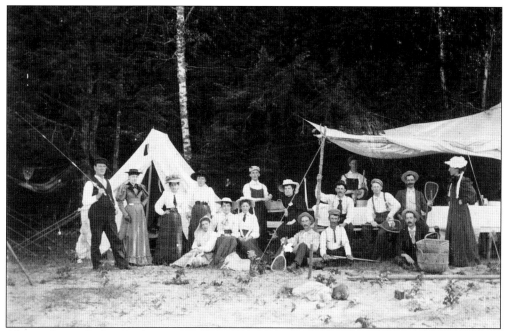

Above, George Robinson (center, next to pole with gun) took advantage of the recently arrived trains to Frankfort and Beulah and started Robinson's Resort in 1891. The span of activities at the resort is clearly seen in the poses struck by the camping party. Fishing, hunting, and racquet sports were available, but also potato peeling and pan scrubbing. One must question what to make of the child laying in the front with a bottle. Below is a picture of the pavilion, taken at the far end of the long dock jutting out into Crystal Lake. The man standing on the fence railing is holding a full string of fish; the woman to the right holds a shorter string.

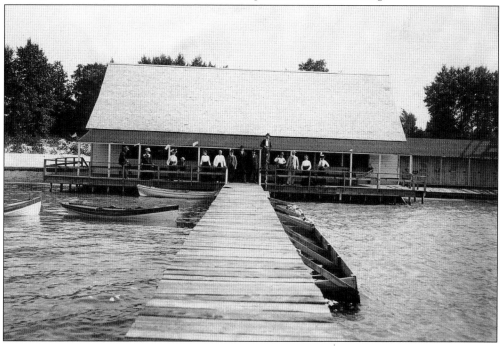

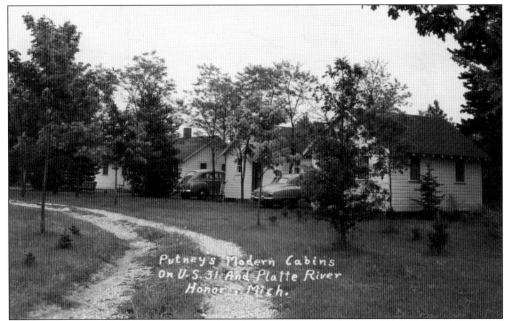

When travel became more economical and convenient with family cars, long-stay resorts gave way to smaller cabins and motels along the highways and rivers. Beaches, fishing, and boating were a several-hours drive from the new Detroit suburbs. Instead of building a cottage on a lake, working-class families could hop into their car for a weekend getaway "up north" or spend their summer break, while waiting for the factory to retool, on the road and taking in all the attractions. Self-directed, they did not need the planned activities, dining rooms, and housekeeping of the traditional resorts and instead chose simply to lodge in small cabins, such as Putney's Modern Cabins, in Honor (above), and Vincent's Lodge Trails End (below), on Bass Lake (now a part of Sleeping Bear Dunes National Lakeshore).

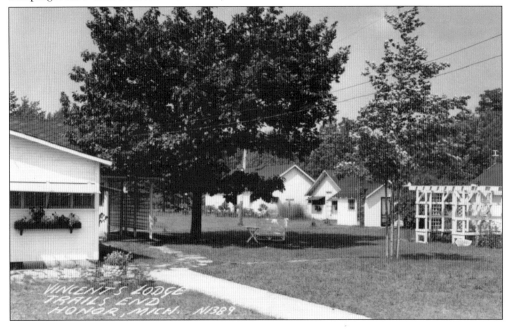

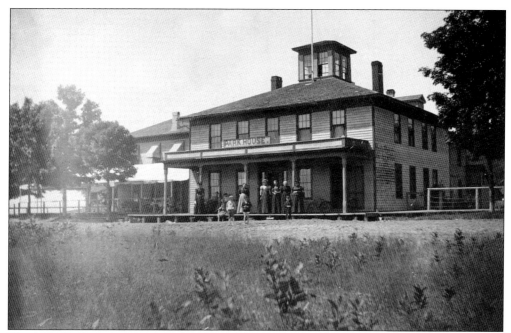

The Park Hotel in Frankfort sat across from the City Park in Frankfort and had views of Betsie Bay and Lake Michigan. At a time when industrial development was new, and promising prosperity for all classes of people, views of the busy harbor with its bustling train yard and railroad ferries provided conversation for visitors lounging on the porch.

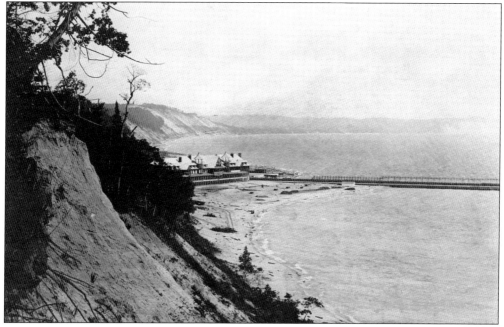

From the bluff overlooking the entrance to Betsie Bay, the long breakwater is seen extending into Lake Michigan. The Hotel Frontenac, built by the Ann Arbor Railroad, sits on the "island" between the Big Lake and the bay. The special railroad tracks laid on the beach, used only by railroad executives for their parties coming to the beach, are just visible.

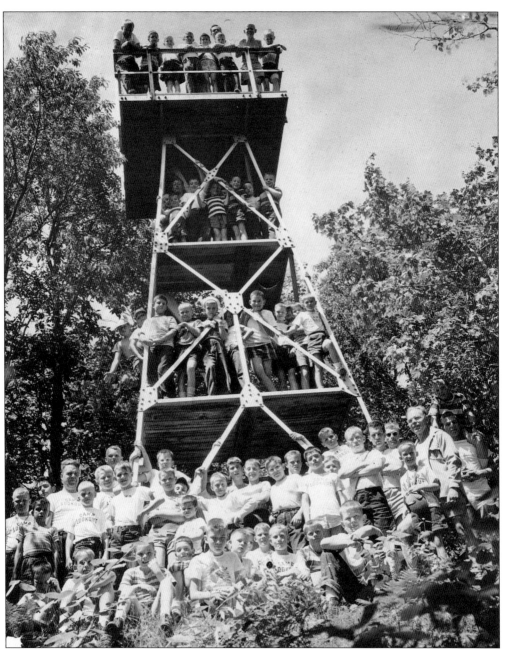

Beginning in the 1910s, separate summer camps for boys and girls were established along the shores of Benzie County's many lakes. Camp Lookout, begun in 1917, was one of the better known camps for boys situated on the narrow stretch of land bordered by Lake Michigan to the west and Lower Herring Lake to the east. It received its name from the lookout tower built in the 1920s, on which the boys appear in a photograph from the 1950s or early 1960s. The lookout tower still stands but is no longer accessible to the modern campers now—both boys and girls.

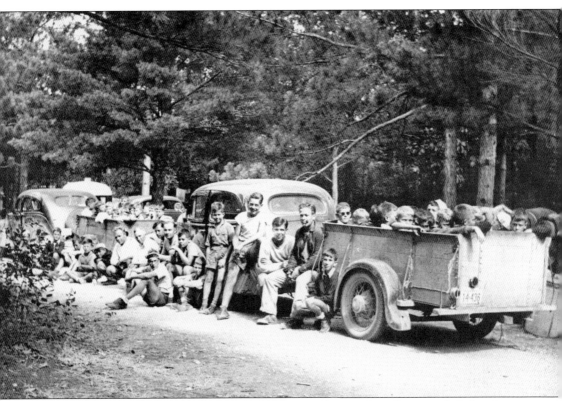

In a much different day, an outing from Camp Lookout to Sleeping Bear Dunes included packing the boys into open trailers and traveling the length of the county and beyond. Travel to and from camp was just as exciting for the boys, and their stories were recorded every year in the camp newspaper the *Spyglass*. In it, they wrote of their adventures on the train, traveling alone and in packs, and picking up friends and food in the cities as they progressed toward Benzie County. Following the custom of the time, to send a boy to Camp Lookout his family had to be a member of the camp, and when their son aged out, they could recommend another family to fill his coveted spot.

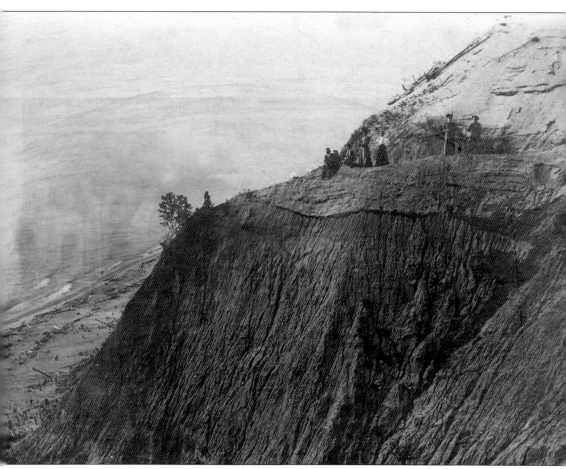

High on the bluff just north of Frankfort, a hiking party takes in the view of Lake Michigan to the west and Frankfort, Elberta, and Betsie Bay to the south. Even in suit coats and ties, or corsets and long skirts, the panoramic view of the rigged schooners, steamships, and tugs busily plying waters of the lakes was well worth the effort of the hike. It was, after all, the waters of the area that attracted them there in the first place and probably served in some way to move them to where they wanted to spend their holiday.

# Five

# SOCIETIES

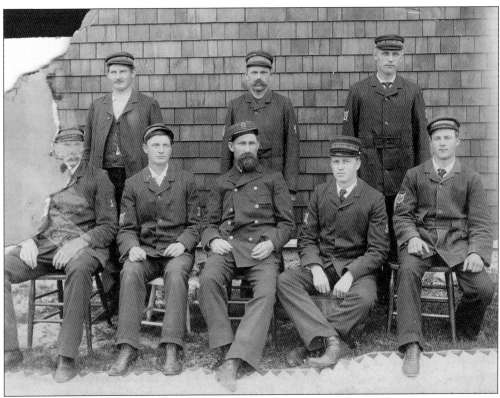

Unidentified members of the Point Betsie Life Saving Station have their picture taken; the life ring and oars on the shoulder of their uniform indicates their service. Many groups tended to have a special uniform to designate their membership, both for public service and socialization. While the purposes, services, and uniforms of Benzie County societies may have changed, their contributions endure.

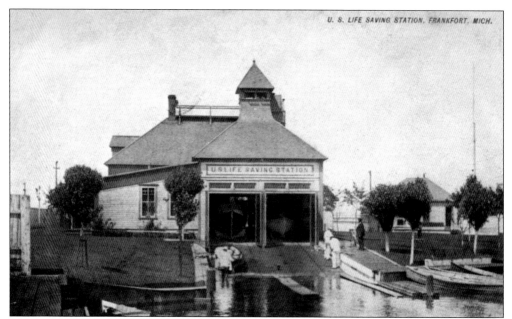

The US Life Saving Service, a precursor to the Coast Guard, had two stations in Benzie County: Frankfort, which operated out of Elberta, and Point Betsie, near the Point Betsie Lighthouse. The buildings occupied by the Life Saving Service were similar. The wooden boats, pictured here at Elberta, rested on a rail and were easily slid down the ramp into the water.

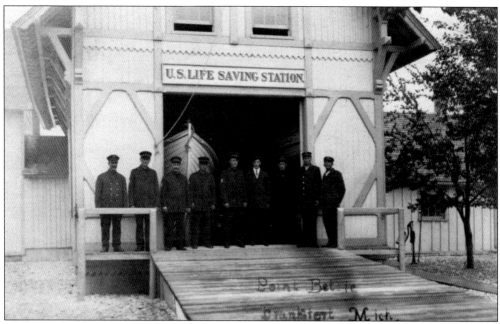

At the Point Betsie Life Saving Station, the keepers (officers) and surfmen of the Life Saving Service are distinguished by their uniforms. They are, from left to right, E.E. Bedford (keeper), Charles Gall, Barney Burnier, Bill Tilgard, David Stoward, John Bennet (sub), Roy Oliver, Phil Sheridan (keeper), and Fred Bennett (keeper).

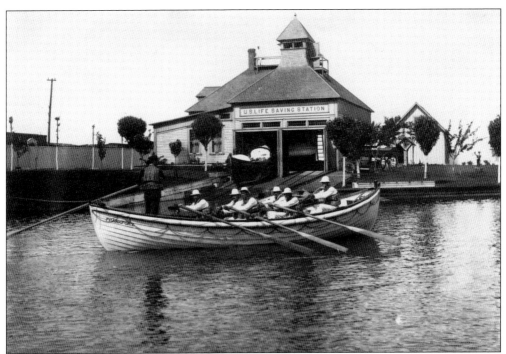

The Great Lakes acted as great inland seas of the Midwest, with Lake Michigan containing some of the most frequented lanes. Point Betsie marks the farthest point west in Lake Michigan, and it also indicates the start of a hazardous channel that runs between the west coast of Michigan and the Manitou Islands. One of the duties of the Life Saving Service was to patrol the beaches for hazards and ships in distress. To accomplish this, members would walk the beaches for two-and-a-half-mile stretches or drill with their boats. Above, the team from the Frankfort station drills on Betsie Bay. Below, the crew from Point Betsie returns from its patrol, with the lighthouse visible in the upper right corner.

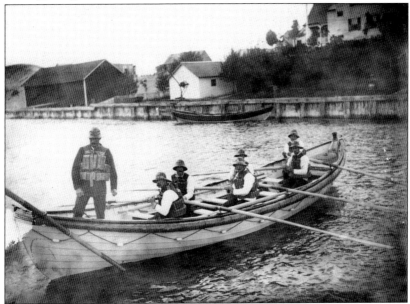

At the Frankfort station, a photograph from 1909 shows "The Giving Men." They are, from left to right, (first row) Lud Hendrikson, Roy Oliver, and Elmer Ness; (second row) Sig Frey, Charlie Gaul, Captain Bedford, and Charlie Stibbets. Remarkable stories are told of their braving high seas in wooden boats to rescue men and women in damaged ships.

Members of the Life Saving Service were expected to do more than simply man the boats and patrol the beaches; they were also responsible for the building and maintenance of their living quarters, sometimes in rather isolated places. In a picture from 1894, they whipsaw their lumber—and will go on to make their shingles.

A critical piece of equipment for the Life Saving Service was the beach cart, which when loaded with all the needed equipment weighed close to a ton. To move it to an emergency, it was pulled by two surfmen, pushed by two surfmen, and steered by two surfmen. Its placement and operation was determined by the keeper.

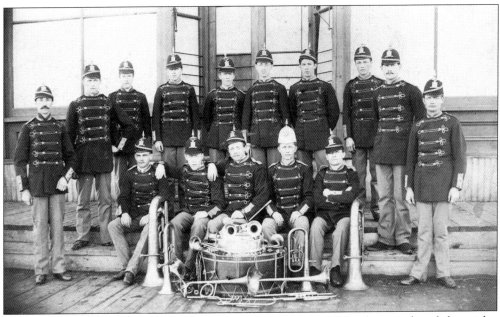

The South Frankfort (Elberta) Band pose for a photograph in 1896. They are, from left to right, (first row) bandmaster Burt Perry, Bill Blacklock, Everet Glarum, Charles Lowder, and Tim Elliott; (second row) George Rupright, Rasmus Vergland, Harry Greggs, Harley Schaeff, Fred Lowder, Clayton Perry, Mark Gudemous, Otto Gudemous, Charley Greggs, and Roy Kibby.

Veterans from the Civil War played a critical role in the growth and development of Benzie County, as they were drawn to the area by the strong abolitionist sentiments of its first settlers. As members of the Grand Army of the Republic (GAR), they were provided places of honor and accorded the respect due to those who sacrificed so much for the preservation of the Union.

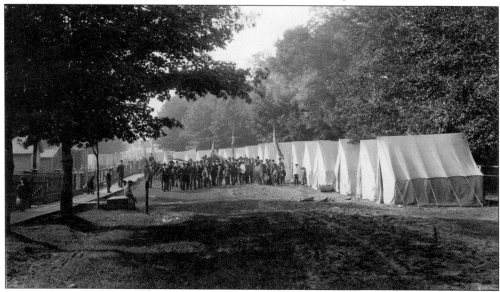

The members of the GAR regularly held reunions and marked special anniversaries with encampments. The reunions involved speeches and dramatizations, and on Memorial Day lilacs were laid on the graves of those veterans who had passed. In 1889, this white-tented GAR reunion encampment was recorded on First Street in Frankfort.

A 1910 postcard picture is taken of "a bunch of old comrades" at the 19th annual reunion of the GAR, held in Honor. As their numbers decreased, the encampments became smaller. The white headquarters tent is a symbolic marker of a time when entire vacant lots were taken up by the white tents, and many men dressed in blue uniforms and black campaign hats told their stories.

Bruce Catton (left) and Robert Catton, veterans of World War I, are pictured in their uniforms. As children in Benzonia, they grew up among the men of the GAR and listened to their stories. Robert would go on to become a renown Congregational minister, while Bruce became an authority on the Civil War, winning the Pulitzer Prize for A *Stillness at Appomattox*, his book about the end of the war.

Above, instead of volunteer firefighters, these are the Modern Woodmen of America (MWA) dressed in their uniforms and standing ready with their axes. Fraternal benevolent societies, of which the MWA is an example, were very popular before worker's compensation and state-regulated insurance companies paid benefits. They were also an opportunity for business networking and socializing. Restricted memberships, uniforms, public service, and pseudo-religious ceremonies were common features of such organizations. Many eventually became full-fledged insurance companies, quite similar to today's entities, while others grew into labor unions. Out of the thousands that existed in the 18th century, few survived unchanged into the late 20th century. Below, an unidentified organization assembles with its banner and insignia.

Any reason could be given for the gathering of a society, as evidenced by the Fat Men of Honor, who pose for a picture in 1909. Pictured from left to right are (first row, sitting) John Rotter, Warn Miller, Walter Scott, Alex Morris, Frank Weaver, and J.P. Covey; (second row, standing) Ernest Haase, Dr. Row, ? Nickles, Alfred Trip (center), George Weaver, Chartel Wall, Fran Weaver, Grandpa Weaver, Hank Ryan (between shoulders), and Andy Todd.

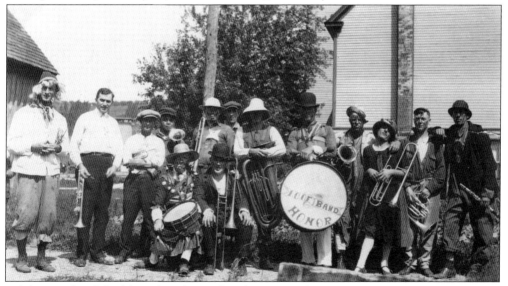

While many bands had formal uniforms, the Thompsonville Odd Fellows had a clown band. The members seen here include, from left to right, (first row) Harry Jaques and Bill Hobson; (second row) Al Martin, unidentified, Jersal Martin, four unidentified members, John Peckins (with big drum), Dave Vandervort, unidentified, Jack Brown, and Walter Armstrong.

Throughout Benzie County, its waters teeming with fish and woods full of game, hunting clubs of year-round residents formed to take advantage of the abundant wildlife and the time they could spend together in their camp. In Honor, one of the better-known hunt clubs was the Honor Stimulating Club, their banner unfurled at the hunting camp above. Deer and rabbit were their main quarry when out in the woods and fields, and many photographs were taken of their buck poles. However, hunting was not their only occasion to gather, as demonstrated by the photograph below of a formal dinner at the Brundage Hotel in Honor.

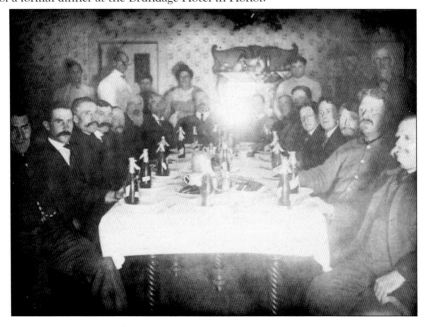

Hunting deer does not require membership in a hunting club, but membership very often gives the hunter an opportunity to spend some time with friends at a deer camp in a club-like atmosphere. For some, stalking the deer is of secondary importance to the socialization, such as the above group from 1899 gathered in the woods. Members include, from left to right, Walter Towner, John Pakins, unidentified, Warn Weaver, John Eake, unidentified, and Jorg Webster. Below, the deer camp has changed little over the course of a century. Orrin Towner (left) and Barney Brzosky stand at their buck pole with some of the essentials of camp in ready supply.

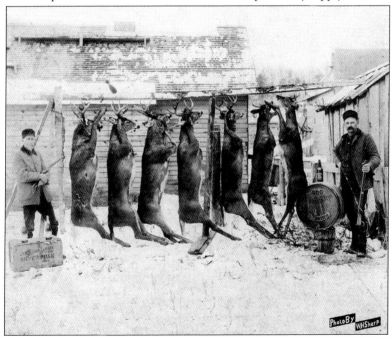

At a time when the only music to be heard was performed live, bands and musical clubs were found in every community, and most people were able to play a musical instrument or sing. Even in a town as small as Benzonia, children were able to take violin lessons, and piano and organ lessons were given by church organists and schoolteachers. In a picture taken in March 1893, members of the Benzonia Guitar Club pose with their instruments. They are, from left to right, (first row) Miss Philps; (second row) Eugene Case, ? Burger, and ? Hoffman; (third row) Maggie Montgomery, ? Matthune, and Frankie Minier.

Appropriately unidentified, and the location unknown, this photograph of ghosts is probably from the Benzonia Academy. It is labeled only "Ghost Party, October 31, 1907." Before televisions and radios were in front rooms, kitchens, and bedrooms, and even before movies were on the screens in small-town theaters, local productions of skits and plays, costume parties, and dances were the fun way to seek out entertainment for the evening. In Benzie County, many of the sites for these events are physically gone, some even lost to living memory, but their spirit and the impact of the settlers' decisions live on amongst the woods and waters of Benzie County.

# www.arcadiapublishing.com

Discover books about the town where you grew up, the cities where your friends and families live, the town where your parents met, or even that retirement spot you've been dreaming about. Our Web site provides history lovers with exclusive deals, advanced notification about new titles, e-mail alerts of author events, and much more.

Arcadia Publishing, the leading local history publisher in the United States, is committed to making history accessible and meaningful through publishing books that celebrate and preserve the heritage of America's people and places. Consistent with our mission to preserve history on a local level, this book was printed in South Carolina on American-made paper and manufactured entirely in the United States.

This book carries the accredited Forest Stewardship Council (FSC) label and is printed on 100 percent FSC-certified paper. Products carrying the FSC label are independently certified to assure consumers that they come from forests that are managed to meet the social, economic, and ecological needs of present and future generations.

FSC
Mixed Sources
Product group from well-managed forests and other controlled sources
Cert no. SW-COC-001530
www.fsc.org
© 1996 Forest Stewardship Council

*Find Your Place in History.*